Colour
Photography

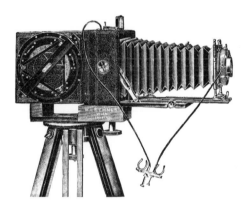

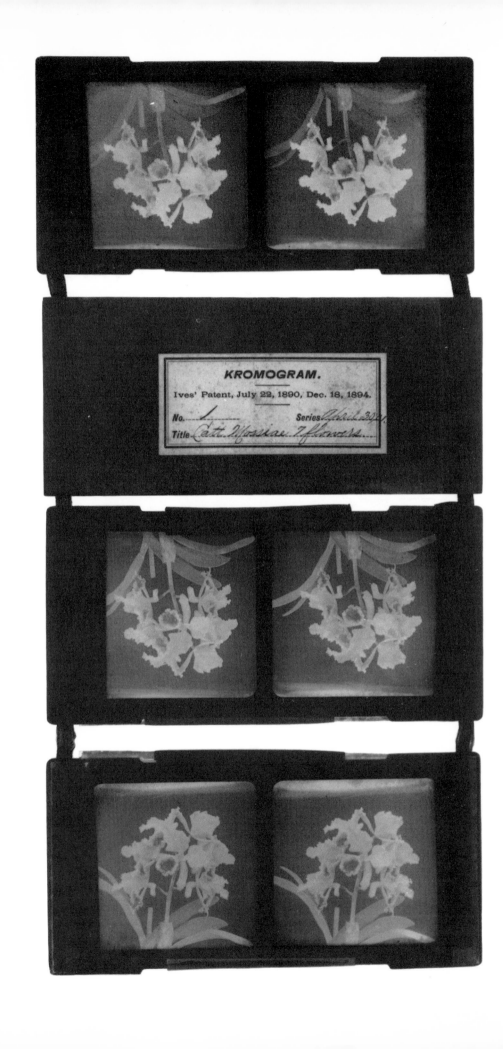

Colour Photography

The first hundred years 1840-1940

by BRIAN COE

Curator of the Kodak Museum

ASH & GRANT

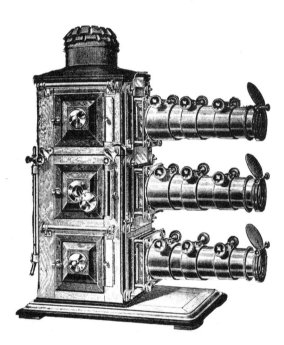

Ash & Grant Ltd
120B Pentonville Road
London N1 9JB
England

First published 1978

Colour Photography text © Brian Coe 1978

Designed by Nicholas Maddren, Campion Design,
Baldock, Hertfordshire, England

Casebound ISBN 0 904069 23 0
Paperback ISBN 0 904069 24 9

Printed in Great Britain by
Balding + Mansell Ltd, Park Works,
Wisbech, Cambridgeshire

British Library Cataloging in Publication Data

Coe, Brian
 Colour photography.
 1. Color photography – History
 I. Title
 778.6'09'034 TR510

Page 1 *R. Lechner's camera of 1912*

Page 2 *A stereoscopic Kromogram, exposed in April 1901*

Page 4 *Lancaster's triple lantern*

Contents

Introduction

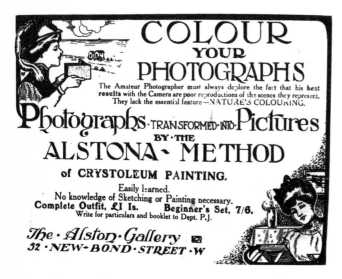

1907 advertisement for materials for crystoleum painting

In the years since 1861, when the first colour photograph was made, many fortunes have been spent (although few have been made) in the search for a simple, commercially workable process of colour photography. This book outlines the principal developments which led to the forms of colour photography we use today. We will consider the story of colour photography up to the 1940s, by which time the basis of all modern processes had been established. To discuss the great proliferation of commercial processes in the post-war years would be beyond the scope of this book; suffice it to say that none of them is based on principles fundamentally different from those of the processes described in Chapter Five. Furthermore, operating procedures, formulae and processing details, as well as the more advanced physical and chemical principles involved, cannot here be covered in more detail than is necessary to describe the essential differences between those methods which reached the public. Such details, together with information on many of the unsuccessful processes, must be sought from some of the sources listed in the bibliography. Of the many processes developed for colour motion pictures, only those which led to, or were also applied to, still photography will be discussed here.

It is necessary at the beginning to say something about the nomenclature of colour, which can be a source of great confusion. Traditionally, the primary colours of the artist have been red, blue and yellow, colours which when mixed on the palette can yield any other colour required. The photographic primary colours, on the other hand, are red, green and blue. The difference is only in the names. Red, green and blue are pure colours, found in the spectrum produced by Newton's

classic experiment of splitting up white light by passing it through a prism. Mixtures of light of these three colours will reproduce all others. In reality, the artist's 'primaries' are mixed colours. 'Red' is a blue-red colour, corresponding to the secondary colour magenta. 'Blue' is a blue-green, corresponding to the secondary colour cyan. Yellow is also a mixed colour, which can be produced by mixing red and green light. Thus, when an artist mixes 'blue' and 'red', the result is a blue colour, similar to the blue of the spectrum, since blue is a colour common to both. Yellow and 'blue' produce green, the colour which they both contain, while yellow and 'red' produce the primary red colour. These colour mixtures are, as we shall see, the basis of many colour photographic systems. There is not one colour law for the artist and another for the scientist or photographer; there is merely a semantic difference. In this book, the scientific terminology will be used, except, of course, where quoting from original sources where the traditional terms are used.

Monetary prices are quoted in their original form. Owing to inflationary trends and fluctuating exchange rates, conversions into modern equivalents and other currencies can be misleading. Some decimal equivalents of pre-decimal sterling currency are: 6d = $2\frac{1}{2}$ pence; two shillings or 2s = 10 pence; one guinea = £1.05. As a point of reference, in the late 19th century a day's wage for an unskilled worker was about one shilling, while a skilled chief operator in a London photographic studio might have received ten shillings a day.

I would like to acknowledge the help of the following: Mr John Ward of the Science Museum, London, for giving access to the collection of colour photographs held there; Mr Ray Causer, of the Kodak Research Laboratory, for help with the preparation of photomicrographs of screen plates; Mr Roger Flint, also of the Kodak Research Laboratory, for the production of the scanning electron micrographs; and Mr Peter O'Connor, my colleague in the Kodak Museum, for his work in the preparation of the illustrations.

In addition I would like to thank the following for permission to reproduce items in their possession:
The Science Museum, London, 54 (right), 58 (top), 59 (top), 62, 70–1, 75 (below), 78 (top, below left), 88
Herr Gert Koshofer, Deutsches Photographische Gesellschaft, 122 (below)
Mr C. H. Wills, 93
Dr R. W. G. Hunt, Kodak Research Laboratory, 24–5
The remainder of the illustrations are from the collection of the Kodak Museum.
The diagrams are by Andrew Farmer.

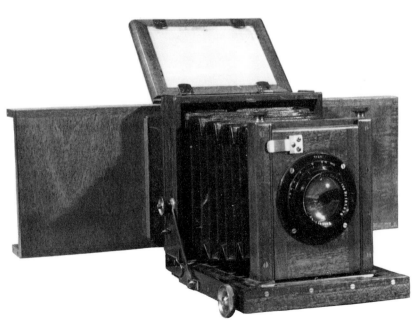

The Sanger-Shepherd Folding camera, 1905

1 The search for colour

An advertisement for a colouring service for photographers, from the British Journal of Photography Almanac *for 1861*

Right Newman's Photographic Colors *were widely used for colouring Daguerreotypes, collodion positives and albumen prints. A hand-coloured stereo-Daguerreotype is shown on page 18. This advertisement dates from 1859*

From the introduction of the first photographic processes in 1839, the sense of wonder of many of those who saw the new 'light drawings' was tempered with disappointment that the colours of Nature, as well as its forms, were not recorded. In an attempt to remedy this deficiency, it soon became the practice to add colour to the monochrome photographs. Of the two photographic processes announced in 1839, that described by the Englishman William Henry Fox Talbot was the most easily coloured. Talbot's 'Photogenic Drawing' process used sensitised paper sheets which when exposed for long periods in a camera produced negative images, which could then be printed on to similar paper to make positive prints. Such prints, and especially those produced by his improved Calotype process of 1840, could be coloured easily with water-colours or transparent oil paints. From 1843, at Talbot's photographic establishment at Reading, and from the London studio in Regent Street, his assistant, Nicholas Hennemann, sold rather crudely coloured Calotype prints, both portraits and scenes. He charged 3s 6d for coloured prints which sold for less than half that in the original monochrome form. Talbot however was not enthusiastic about the results!

Prints on the matt-surfaced, uncoated 'salted paper' used to print Calotype negatives took colour easily, the paper retaining and absorbing the colours. The rival Daguerreotype process, on the other hand, gave less scope for the addition of colour. Produced on the polished silvered surface of a copper plate, the Daguerreotype image consisted of tiny particles of a mercury-silver amalgam, easily brushed from the surface of the plate. Painting over this delicate image in the

NEWMAN'S PHOTOGRAPHIC COLORS,

For the Silvered Plate—Glass—and Paper.

These Colors are *prepared by a peculiar process*, meeting every want of the Photographer. They adhere with ease and fulness to the Plate; while, from their transparency, they *colour without hiding* the Photograph, giving a pure, brilliant, and *life-like* effect.

THE FOLLOWING ARE SOME OF THE PRINCIPAL COLORS.

Flesh, Fair, 1 2	3 Complexions	4 Greens
Ditto, Dark, 1 2	Carmine	3 Browns
Lips	4 Yellows	Permanent Scarlet
Lavender	Golden Yellow	Carnation
Black	Orange	3 Greys
Crimson	Puce	Silver Grey
Pink	Rose	Violet
Horizon	Distance	Puce
White	Satin White	White (Solarization)
Damask	Plum	Claret
Backgrounds	Mauve	&c. &c.

In Bottles, sealed and tied over, Price 1s. each.

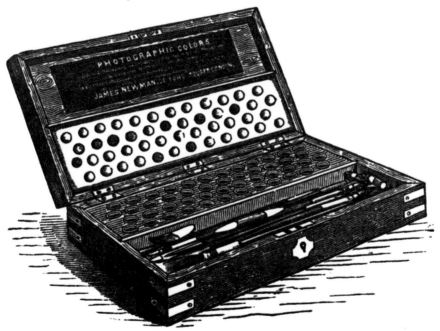

			£	s.	d.
Lock Mahogany Box, with Velvet Palette, Brushes, Stumps, Shells, &c., and 36 Colors			2	2	0
Ditto ditto with 24 Colors			1	11	6
Ditto ditto with 18 „			1	5	0
Ditto ditto with 12 „			1	0	0
MAHOGANY Box, with Brushes, &c., 9 Colors			0	10	6
SLIDE BOXES, containing any number of Colors, with Brushes, Stumps, Shells, &c.					
ALBATA AND BRASS-BOUND DOVE-TAILED MAHOGANY BOXES, with extra reserve of Colors, Brushes, Stumps, &c., for hot climates, from			2	2	0

THE

PRINCIPLES AND PRACTICE

OF

HARMONIOUS COLOURING,

IN

OIL, WATER, AND PHOTOGRAPHIC COLOURS,

ESPECIALLY AS

APPLIED TO PHOTOGRAPHS

ON

PAPER, GLASS, AND SILVER-PLATE.

BY

AN ARTIST-PHOTOGRAPHER.

SECOND EDITION.

LONDON:

W. KENT & CO., 51 & 52, PATERNOSTER ROW;

AND

JAMES NEWMAN, 24, SOHO SQUARE, W.

1859.

The title page of a popular book on the techniques of hand colouring of photographs, 1859

ordinary way would not have been practical, yet the cold, grey, metallic character of the image seemed to call for colour even more than the warm brown monochrome of the Calotype print. *Blackwood's Magazine* reported in 1842, 'The likenesses produced . . . are so absolutely fearful, that we have but little hope of ever seeing anything tolerable from any machine. It must want colour . . . and its best likeness can be only that of a rigid bust, or a corpse'. In that year the London licensee of Daguerre's English patent, Richard Beard, patented methods of colouring Daguerreotypes. He suggested that stencils be prepared, cutting out from tracing paper the shapes to be tinted in each colour: 'The dry colours are ground to an impalpable powder in a solution of gum arabic or other adhesive material; they are then dried and sifted; in using them they are allowed to settle from a suitable box on to the screened picture, the screen is withdrawn . . . the colour removed from the shadows by blowing with bellows, and the remainder fixed on the plate by breathing'. He further suggested that the underside of the protective glass might be coloured with transparent paint mixed with water and gum. His third method was that which was most widely adopted: 'The dry colours are stippled with a camel-hair pencil on to the different parts of the picture, using the colours required for each part. The colours are successively set by breathing over them'.

W. H. Thornethwaite's *A Guide to Photography* of 1852 described the usual method for colouring Daguerreotypes:

'The picture must be well set with gold [that is, gold toned to render it less fragile] and the colour applied or dusted on with a fine camel's-hair pencil, taking up a very small quantity of colour at a time, removing the superfluous colour by blowing it off with a caoutchouc bottle; when the desired tint is produced, breathing on the plate will cause the colour to adhere. Mr Claudet's method is to mix a small quantity of the colour with spirit of wine, applying it to the plate with a camel's-hair pencil, and if not sufficiently dark, some of the dry colour is applied over it, to which it will adhere. As a general rule, the colours should be applied very cautiously, as it is very difficult to remove them when once on the plate. The best colours to be used are carmine, chrome yellow, and ultra-marine, by combining which any desired tint may be obtained'.

Colouring outfits were offered by various suppliers. For example, in 1852 J. J. Griffin and Company offered:

'Colours for painting Daguerreotypes.

22. Box, containing 10 Colours in Glass Tubes, with a Cup of Silver, a Cup of Gold, and a set of Brushes, 10s.6d.
23. Single Colours, in Tubes, 1s. each.
24. Cup of Silver, 6d.
25. Cup of Gold, 8d.'

A significant proportion of surviving Daguerreotypes show some evidence of colouring. Usually, the colours are subtle and subdued; often, no more than gold paint embellishment was used to highlight rings and other jewellery. *Harmonious Colouring as Applied to Photographs*, by 'An Artist-Photographer', and published by James Newman in 1859, was critical of many of the results:

'. . . so imperfect was the preparation of the colours, and so inefficient the method of using them, pictures were, for many years, as frequently spoiled as improved. The colours sold were often utterly worthless, and the instructions for their use we have seen on more than one occasion to have been to the effect that they were to be "dusted over the picture"!'

Naturally, those produced by Newman himself produced 'very beautiful results'. The book stressed that 'an elastic India rubber bottle, with tube, will be required, for blowing off superfluous colour, as blowing with the lips should in no case be attempted, on account of the danger of spotting the picture with moisture'.

The 1850s saw a rapid growth in photography, as Frederick Scott Archer's wet collodion process, published in 1851, swept away the earlier Calotype and Daguerreotype processes. A version of this process gave a positive image on glass backed with black paint or other material. These collodion positives could be produced very cheaply, and had a superficial resemblance to the more costly Daguerreotypes. They too could be tinted with dry colours, and Newman's book suggested that after the excess colour had been blown away with the rubber bottle, a suitable varnish could be run over the plate to fix the colour. When dry, extra colour could be applied to the varnish layer. An improved form of printing paper, coated on the surface with a thin film of egg-white, or albumen, was suggested by Louis-Désiré Blanquart-Evrard in 1850, and soon came into general use, replacing the matt 'salted paper' of Talbot's process. The new paper had a smooth, slightly glossy surface which, while improving the sharpness of the prints, made painting on it more difficult. *The Dictionary of Photography* (1890) observed, 'Water-colours have

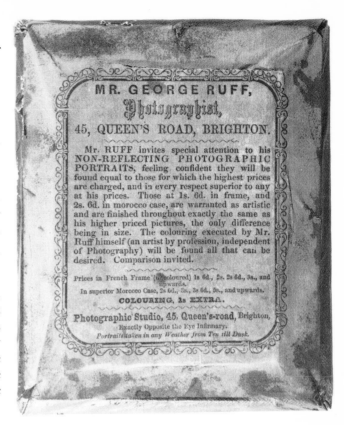

An advertisement on the back of a collodion positive photograph, c. 1856, offering the supply of artistically coloured photographs

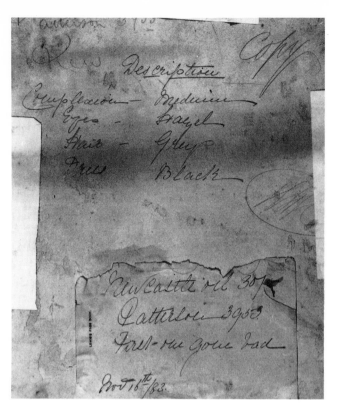

Instructions for a colourist, written on the back of a mounted albumen print of 1883. The work, in 'Newcastle oils', cost 30 shillings

a decided objection to adhere to the glossy surface of an albumenised print, but they may be made to do so by applying a weak solution of inspissated and purified ox-gall'. The ox-gall acted as a wetting agent, allowing the colour to flow evenly over the surface of the print. As well as water-colours, which were usually of the kind used by miniature painters, the dry colours or oil colours could be used to colour prints on albumen paper. Newman's book laid down the ideal type of photograph for colouring:

'. . . it is necessary that the photograph approximate in some degree to excellence. It is important that the distribution of light and shade in the picture be effective and natural, that it be sharp and in focus throughout, and that it be a clear, bright, well defined photograph . . . For water colours, the tone of the picture is of considerable importance. A warm neutral tint or grey is the best tone for colouring. Heavy shadows of purple brown, or of an inky tone, are very undesirable'.

The book warns that

'it is necessary at the outset for the amateur to know something of the principles on which painting in water-colours is based. The photographer entirely unacquainted with these principles will probably be surprised to ascertain that, by mixing his colours to the desired tint, and then simply washing them on to his photograph, he will produce but a woefully meagre and unsatisfactory result. The effect would be little better than a flat insipid imitation of the multitude of coloured prints which abound in the windows of stationers' shops about the 14th of February'.

Commercial photographers usually offered to supply portraits plain or coloured; for example, in 1855 the Photographic Institution in New Bond Street, London offered:

'Portraits Taken (Under Mr. Fox Talbot's Licence).

Mounted in a plain glass frame	£1	1	0
Extra copies, each	0	5	0
Tinted face and hands	3	3	0
Coloured Portraits, *in the best style*	5	5	0
Groups, or large-sized Pictures, Coloured from	7	7	0'

The popular carte-de-visite photographs from around 1860, and the cabinet-sized photographs from around 1866 often advertised on their backs that the photographer could produce copies coloured in oils, water-colours or crayons. The stereoscopic pictures on card which were popular in the 1850s and 1860s were often also offered in

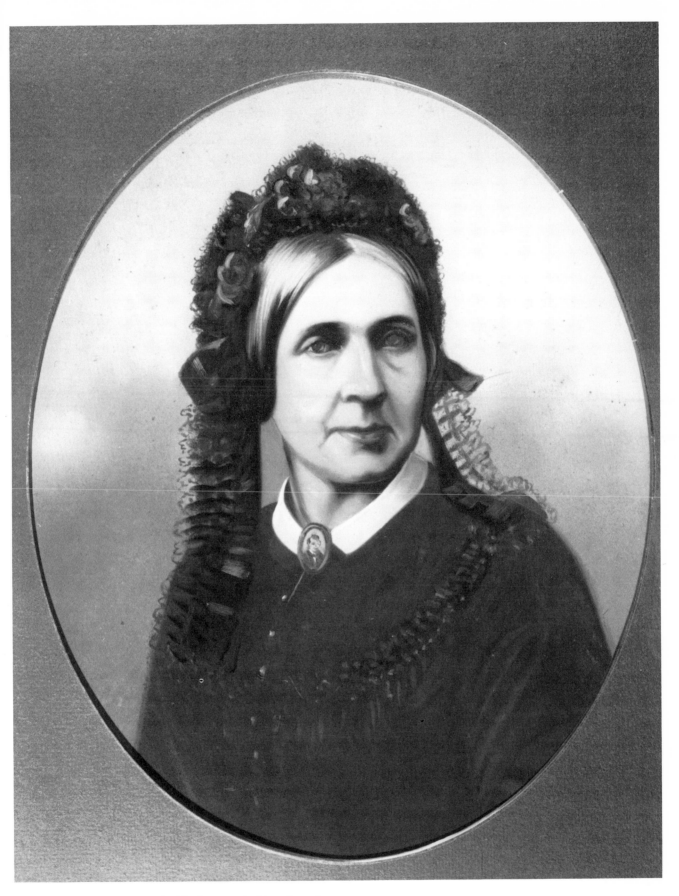

The coloured albumen print itself, photographed here in such a
way as to reveal the artist's hand-work

The carte de visite size photographs, popular from around 1860 to the early 1900s, often advertised a service for the supply of coloured photographs

coloured versions. Much of this colouring work was done by miniature painters whose businesses had been ruined by the advent of photography. Madame Una Howard was reported in the American *Humphrey's Journal* in 1865 as suggesting that

> 'some systematic effort should be made to teach the art of colouring photographs to destitute ladies . . . calculated to afford employment to many young ladies who, being left in straightened circumstances, have yet, while their natural protectors were living and could afford it, received lessons in painting. Many honourable and right honourable ladies have kindly formed themselves into associations to promote the employment of those respectable yet bereaved beings'.

Apart from the straightforward colouring of photographs on the surface, there were several methods which involved attaching the coloured albumen print to glass. Laloue's 'Daguerreotype à l'Huile' process of the mid-1850s involved painting over a portrait on albumen paper with oil paints, and then covering the print with a sheet of glass to which it was stuck with a film of varnish. The picture thus received a high gloss surface, which enhanced the brilliance of the colours. In the 1850s, and later, a number of suggestions were patented for colouring photographs from behind, once the paper had been rendered transparent by waxing or varnishing. One widely employed method produced what became known as crystoleums. The method was derived from an 18th-century technique known as mezzotint painting, where prints or engravings would be coloured through the paper from behind. The crystoleum was made by attaching an albumen print face down on the inside of a curved glass plate, using gum or paste to cause it to adhere perfectly. When dry, the paper was rubbed down with sandpaper until only the very thinnest layer of paper was left attached to the albumen film. A slow drying oil or wax was then used to make the print completely transparent. All the fine details of colour were then painted on to the back of the picture, using ordinary oil paints. A second curved glass was then placed behind the first, and the broad areas of colour were painted on the back of this. Finally, the whole was backed with a white card and bound up together. The necessary glass, special solutions and gums were commercially available until the First World War. The thin paper 'transparencies' frequently used in stereo-scopes in the 1860s were often coloured on the

back, so that if the direction of illumination was changed from the front to the back, an apparently monochrome picture was transformed into a coloured one. Such 'dioramic' effects were derived from those seen in late 18th-century peepshows, which used engravings coloured from behind, and lit alternately from front and back.

From the 1850s, photographic slides for the magic lantern were often tinted with transparent colours to enhance the effect on the screen. This presented the colourist with severe problems. The pictures were no more than three inches square, and yet might be thrown on to a screen twenty or more feet wide. Observing that so many coloured lantern slides were unsatisfactory, the Rev. F. C. Lambert, in his book *Lantern Slide Making* (1901) outlined the usual problems:

'*(a) Crude and tasteless colours* – The colours used are, as a rule, far too vivid, glaring, crude and bright, such as Prussian blue sky with crimson-lake clouds. It is far, far better to err on the side of quietness of colour . . . *(b) Excess of colour* – This, again, is a common fault. Not only is the wrong crude colour used, but far too much is put on . . . *(c) Faulty outlines* – Here, again, is the result of lack of skill, or impatience. The outlines are not carefully observed, and we thus get sheep with green outlines, and the like . . . Remember that a fine stroke no thicker than a hair, will come out like the branch of a tree on the screen. "Near enough" will not do for lantern slide colouring.'

The commercial suppliers of lantern slides were criticised by 'An Expert' in the book *The Art of Projection* (1893):

'Cheap coloured photographs are done by girls, who are miserably paid, and who have no idea of real art and harmony of colours. The manner in which these girls are brought into the way of earning their livelihood is a study for a labour commission, sweating is not a word strong enough to describe the system under which cheap slides are painted – we should have said daubed. Three colours will often constitute a coloured slide, blue sky, green trees and a brown foreground, and these sell complete including the photograph from 1/- to 1/6 each. To colour and make up a slide, as it should be, will sometimes take an artist a day . . .'

In 1893, the leading magic lantern supplier, W. C. Hughes, could offer 'Slides coloured in the highest

An advertisement, published in 1907, for materials for crystoleum painting, in which the photographs were coloured from behind. An example appears on page 23

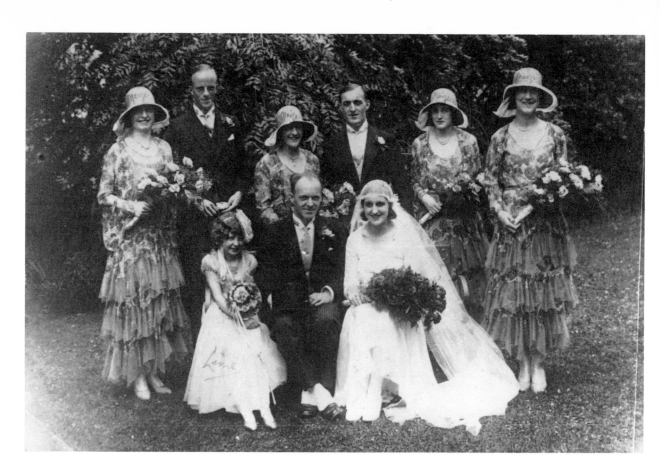

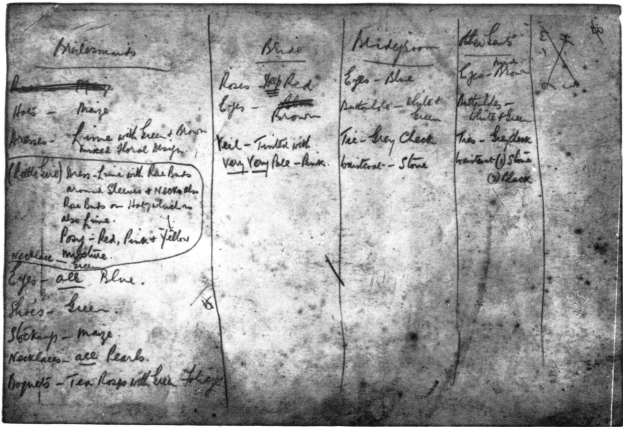

A proof print of a wedding photograph, c. 1930. Detailed instructions for colouring have been written on both the front and back

class manner by Artists who understand their profession, from 9d. to 10/6.' One of the finest lantern slide colourists in England around 1900 was Graystone Bird, a photographer from Bath whose delicately coloured slides were so well finished as to resemble real colour photographs.

The arrival of the new gelatin-based printing papers in the 1880s led progressively to the disappearance of albumen paper, which had largely gone from general use by the beginning of this century. The new papers presented no problem to the colourist; water-based aniline dyes, or water-colours, were absorbed by the gelatin layer, which was generally moistened before painting to facilitate the application of the colours. Commercially produced photographic postcards, which became popular in the early years of this century, were often coloured. The very large editions were coloured through stencils prepared for each colour, as Beard had suggested sixty years before, so that the cards could be rapidly tinted by semi-skilled labour. Most professional photographers in the first half of this century offered coloured photographs as part of their service; the larger studios employed one or more full-time colourists, while the smaller establishments would put the work out. Writing of the problems of portraiture by the colour photographic processes of the day, C. H. Claudy observed in *Camera* in 1920 that in the absence of a foolproof colour process for professional work, 'The very easiest way to get a photograph in colours is to make a good one on plain paper and take it to an artist to decorate with brush and pigment'. This remained the general rule, at least in Britain, until the 1950s. Wedding photographs were among the most popular subjects for colouring, and the photographer would record the principal colours of the dress of the sitters in a notebook, or would consult the customer, marking up a proof print for the benefit of the colourist. A typical order form for a framed water-coloured photograph reads, 'Bridesmaids all blue dressed. Pink carnations. Blue shoes. Pea green bands round head. Little girl band round head pea green, mixed posy. Frock blue & little boy all blue'. That order cost the customer 17s 6d in 1932.

All the methods of hand colouring of photographs used up to 1940 had made use of colours applied over a monochrome photographic image. Great care had to be taken that the overpainting was not done too heavily so as to obscure the fine details of the photograph. With oil paints in particular, this called for great skill. In 1940, Jack

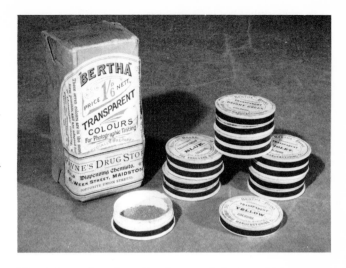

'Bertha' powder colours for photograph tinting which were on sale in England from 1905

Crawford's Flexichrome Company introduced the Flexichrome process for the production of coloured photographs. An ordinary black-and-white negative was printed on to a special material by which the various tones of the image were converted into a relief image in the gelatin layer. The darkest parts of the positive image were represented by a greater thickness of the gelatin layer, the lighter parts by a thinner layer. This clear relief image was dyed with a neutral grey modelling dye to reveal the picture. Suitable Flexichrome tints were then applied by hand, each dye discharging that which was already there. Thus, applying a red dye discharged, at that point, the grey modelling dye. If the wrong colour was applied, it could be removed by simply applying the correct colour in successive applications until the correct hue was obtained. The final result was an image in pure colour only, the choice of colour being determined by the colourist, but the depth of colour and tone were determined by the original photograph. Materials for the process were made and distributed by the Defender Photo Supply Company of America. The Flexichrome process was discontinued by Defender in 1942, but was reintroduced by the Eastman Kodak Company in 1949. Although the Flexichrome process represented a very effective method of producing a coloured photograph, it was, with its less sophisticated predecessors, an arbitrary method of representing colour. It did not, indeed could not, reproduce the scene exactly as it was when the picture was taken.

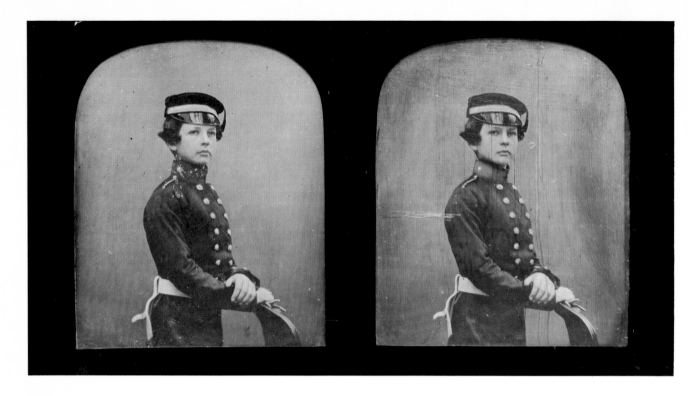

Above *Hand-coloured stereo-Daguerreotype, c. 1855, by Antoine Claudet. Claudet, in addition to his profession of Daguerreotype portrait photographer, was a leading researcher into photographic processes. His colouring method involved applying colour mixed with alcohol, reinforcing this with dry colours where stronger hues were required (57 × 68 mm)*

Right *'Spanish Muleteers at the Fair at Pau, November 1853', by J. Stewart. A calotype print coloured with water-colour, a technique very suitable for the uncoated paper used in this process (110 × 150 mm)*

Far right *Hand coloured collodion positive, c. 1858. The positive image on a glass plate could be coloured, like the Daguerreotype, with dry colours, fixed with a film of varnish. Usually, the colouring involved little more than gold or silver embellishment of rings and other jewellery, but in this case almost the whole image has been tinted (66 × 90 mm)*

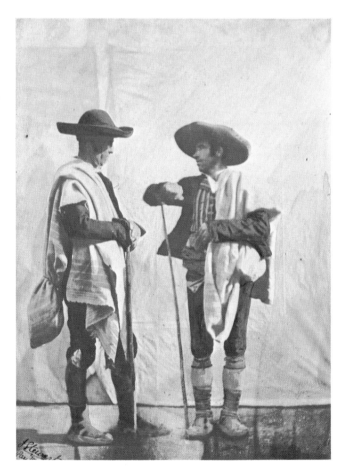

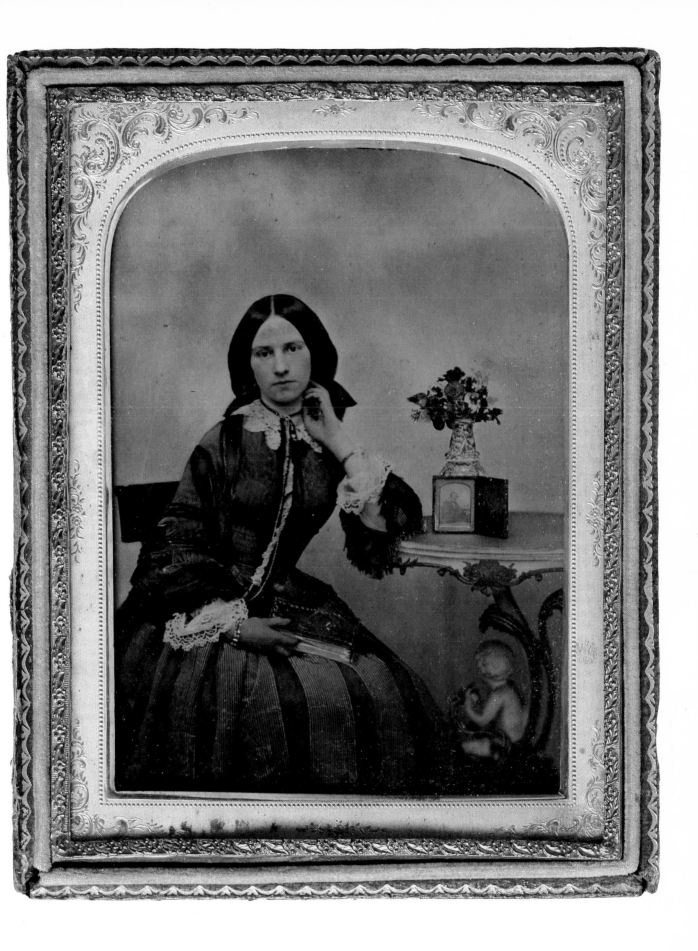

From the beginning of photography there had been hope – even expectation – that soon a way would be found of preparing a sensitive material which would record the colours of Nature directly, and in a manner as simple as that of recording light and shade in a monochrome photograph. This hope had been fostered by the results of an experiment by Johann Seebeck of Jena, who in 1810 repeated some of the earlier work of Johann Ritter on the action of the various colours of the spectrum on silver chloride. Seebeck caused

'the spectrum from a perfect prism to fall for 15 to 20 minutes on white damp silver chloride spread on paper . . . I found the silver chloride to be altered in the following manner: in the violet it became reddish-brown (sometimes more violet, sometimes more blue) . . . in the blue of the spectrum the silver chloride had become pure blue, and this colour extended, increasing and becoming brighter right into the green; in the yellow I found the silver chloride frequently unchanged . . . in the red, on the other hand . . . it had assumed rose-red'.

In 1840 Sir John Herschel published an account of a similar experiment, in which he was able to produce red, green and blue colours corresponding to those of the spectrum cast upon his silver chloride paper; but he could not fix the colours, although by washing the paper they became stable enough to be examined by lamplight. Later, Sir John said, 'I have got specimens of paper, *long kept*, which give a considerably better representation of the spectrum in its *natural colours* than I had obtained at the date of my paper, and that *light* on a *dark ground*; but at present I am not prepared to say that this will prove an available process for coloured photographs, although it brings the hope nearer'.

Louis Jacques Mandé Daguerre, the creator of the Daguerreotype process, observed that when photographing red painted or red brick buildings, the Daguerreotype 'assumed a tint of that character'. In 1848, Edmond Becquerel carried out a series of experiments using silvered plates of the type used for Daguerreotypes, but chemically coated with silver chloride. He managed to produce a fairly satisfactory colour record of the spectrum, but found that by coating the plate electrolytically, by immersing the plate in a solution of hydrochloric acid and passing an electric current from a battery through it, using a platinum plate as the other electrode, a very thin and even film of silver chloride was formed on the plate, which recorded the spectral colours well, although the green was less well rendered than the

other colours. In the 1850s, C. F. A. Niépce de St Victor carried out many similar experiments and obtained not only the spectral colours but also coloured photographs of objects in a camera. He managed to 'fix' the colours by using a form of varnish, so successfully that one of his 'helio-chromes' was said to show brilliant colours forty years after it had been made.

In 1851 an American clergyman, the Reverend Levi L. Hill, claimed to have discovered a process of colour photography on Daguerreotype plates. He proposed to publish full details in a book which would be pre-sold by subscription, at a cost of $5. He collected $15,000, and then published a cheaply printed book which described in essence the Daguerreotype process, but with a number of complicated additional chemical and physical treatments for the plates. The net result of this would have been similar to the process of Becquerel and of Niépce de St Victor. Examples of 'Hillotypes' were shown to only a few people by the inventor. Marcus A. Root reported in 1864:

'The one which fell into my hands, after the publication of Mr. Hill's book, was examined by me under a strong magnifier, and proved to be only an ordinary colored daguerreotype – the dry colored powder being undeniably and distinctly visible on the face and hair. Such was, probably, the substance of the *trick* . . . It seems to have been started merely to get money, and backed up by the respectable title of Reverend, it had a very considerable run'.

In 1865 Alphonse Louis Poitevin described his method for making direct colour photographs on paper. He used silver chloride paper, to which he applied a liquid containing potassium bichromate, copper sulphate and potassium chloride. This paper gave colour reproductions of coloured paintings on glass exposed in contact with it, after ten minutes' exposure, but was not sensitive enough to be used in the camera. He was able to treat his pictures so that they could be preserved in an album, but they turned brown if exposed for long to strong light. A report said: 'his process is far from complete: it renders at present only the least refrangible colours of the spectrum, yellow and red, but is incapable of giving green, blue and violet'.

M. Carey Lea in 1887 published results of research which showed that in the preparation of the Seebeck and Poitevin papers compounds were produced having almost all the colours of the spectrum except green and yellow. Thus, when exposed to the spectrum, those coloured com-

pounds which were closest to a particular spectral colour reflected it strongly, and were therefore not decomposed by it, whilst those which differed from a particular spectral colour absorbed it strongly and *were* decomposed by it. The reason why greens and yellows were not reproduced well by these processes was that compounds of these colours were not present among the various silver compounds formed during the preparation of the paper.

The case of Becquerel's coloured plates was different. Wilhelm Zenker, surveying in 1868 methods of producing coloured photographs, suggested that in the case of images on reflecting surfaces, such as Daguerreotype plates, light falling on the plate would meet light reflected from the polished surface. 'Now, if two waves of the same phase meet, they give rise to the phenomenon which is called, in the case of water "stationary or standing waves".' Thus, if such standing waves were formed in a photo-sensitive layer on a reflecting surface, Zenker predicted that where the peaks of the waves coincided the layer would be exposed, and where the troughs coincided no exposure would take place. During development of the plate thin layers of silver would be formed within the coating, half the wavelength of the particular colour apart, and these layers would reflect light only of that colour when white light fell on the processed plate. The phenomenon of interference colours, which produces the colours in oil slicks, soap bubbles and mother of pearl shell is produced in the same way. Otto Wiener in 1889 confirmed Zenker's theory, demonstrating the existence of standing waves of light, using transparent coatings of silver chloride emulsions in contact with reflecting surfaces.

In 1891, Professor Gabriel Lippmann demonstrated to the French Académie des Sciences interference colour photographs of the spectrum and of stained glass windows, taken by a modification of Wiener's method. An exceedingly fine grained, virtually transparent emulsion of silver bromide in an albumen coating on a glass plate was exposed in contact with a film of mercury, with the glass plate towards the lens. The mercury, in optical contact with the emulsion, reflected light which had passed through the emulsion back on itself, producing the standing waves and layered exposure predicted by Zenker. The developed plate appeared to be a conventional negative by transmitted light, but when viewed at a suitable angle, by reflected light the image appeared as a brilliantly coloured positive. The Lippmann process was taken up with

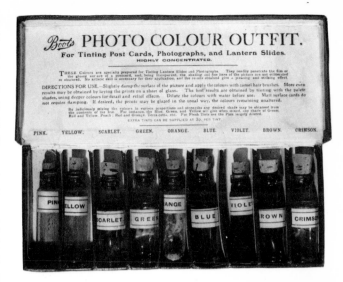

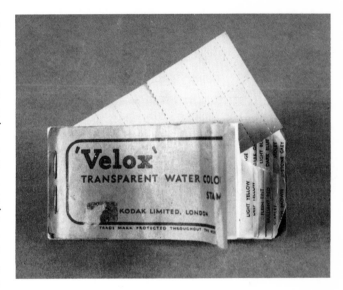

Top *Transparent dyes for photo colouring, supplied by Boots the Chemists in the 1920s and 1930s*

Above *Kodak Velox Water Colour Stamps, popular in the 1930s, were impregnated with water colour dyes, released by placing the stamp in a dish with a small quantity of water*

enthusiasm by the brothers Auguste and Louis Lumière, of Lyons in France. Early in 1893 they demonstrated examples of the process by illuminating them with an electric arc lamp and projecting them on a screen. A report said:

'The great characteristic of these projected pictures is the faithful representation of landscapes. The effect is extraordinary on account of the admirable reproduction of the colours of Nature. The blue of the sky, the greens in their various tints and gradations, with all the most delicate greys and whites – all are here depicted with unrivalled exactitude'.

Right *Albumen print coloured in oils, 1863. Most professional photographers at this time could offer a colouring service for portrait photographs. A relatively unskilled painter could produce a result superficially similar to an original painted portrait in a short time (354 × 455 mm)*

Below *'Daguerreotype à l'huile', by A. Laloue's process, c. 1858. An albumen print, heavily overpainted in oils and varnished, was laid down on a glass plate while the varnish was still wet. This technique gave great brilliancy and a high gloss to the coloured print (200 × 260 mm)*

Far right *A crystoleum portrait, c. 1895. An albumen print was stuck on the inside of a curved glass, and after the paper backing was virtually rubbed away, colours were applied to the print from behind. The technique is described on page 14 (53 × 85 mm)*

23

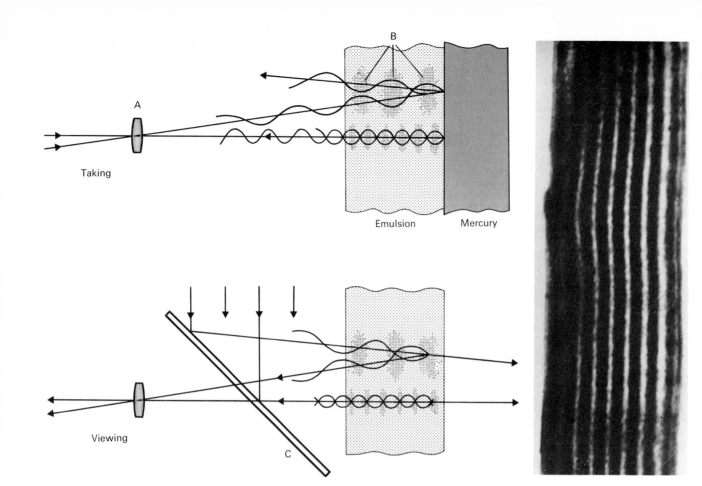

Top *When a Lippman plate was exposed, light from the lens A passed through the transparent emulsion, and was reflected back by the mercury, producing standing waves where the incoming light interfered with the reflected light. A layered exposure was produced at these points, the number of laminae B being determined by the wavelength of light at that point*

Above *When the processed plate was illuminated by reflected light reaching it through a shallow prism or reflector C, the laminae reflected light of the wavelength that had produced them back to the observer, who saw a theoretically exact reproduction of the colour of the original subject. A Lippman photograph is reproduced on page 27*

Above right *A section through an exposed Lippman emulsion, showing the laminae, magnified 20,000 times*

The Lumière brothers coated their plates with a virtually grainless silver bromide emulsion, with an added sensitising dye to make the plates respond to all colours. The exposure was made through a yellow filter, and a landscape required about four minutes' exposure. No real increase in sensitivity, with a reduction in exposure time, was possible without increasing the grain size of the emulsion, and the grains had to be appreciably smaller than the shortest wavelength of light they were to record. Thus, the exposures were over 10,000 times longer than with ordinary negative materials.

Special plate holders were devised in which a space was created between the back of the holder and the surface of the plate by a thin chamois leather or rubber seal, the plate being held against it by springs or clamps. The holders had a hole or pipe at the top through which the mercury could be introduced to fill up the space, and usually a tap at the bottom to run it off after exposure, which had to take place quickly, as prolonged contact with the mercury had an adverse effect on the emulsion. The exposed plate was developed to a negative with a developer of critical composition.

Professor Wiener demonstrated in 1899 that the viewing of the Lippmann plates was greatly facilitated by removing surface reflections from the image, by cementing on flat prisms, of about 10° angle, as coverglasses. Dr Neuhauss, a leading exponent of the process, commented that, with the prisms, 'the colours gained enormously in brilliancy and truth in nature. Pure white actually only appears in the picture after the destruction of the surface reflection'. Despite the severe difficulties, the Lippmann process, with its irridescent colours, fascinated many workers and as late as 1910 Carl Zeiss of Jena were offering complete outfits for its use. By using an f/4.5 Tessar lens, Zeiss suggested that open landscapes could be

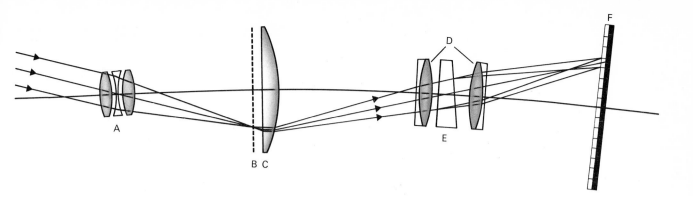

made in one or two minutes, and that with an f/3.5 Tessar lens, portraits might be possible, in sunshine, in as little as twenty seconds.

Although the Lippmann process was the only direct colour photographic method to have any commercial application, one other principle was used for a short time by some workers. The idea was patented in 1895 by F. W. Lanchester, for a process of colour photography by prismatic dispersion. Lanchester's camera used a conventional lens producing an image on a fine grating, ruled with opaque lines at about 300 to the inch. The rays of light passing through the slits in the grating reached another lens fitted with a shallow prism, whose axis was parallel to the lines of the grating. Each ray of light was split into a spectrum, and the image on the plate at the back of the camera was formed from a very large number of these parallel spectra. At any point on the image, the amount of the spectrum transmitted to the plate was determined by the colour of the object photographed. The negative was printed by contact on to a positive plate, which was placed in a viewer or optical system identical to that in the camera. Indeed, the camera itself was often used to view or project the images, by illuminating the plate placed in its original position in the back. The colour was recreated by a reverse process to that which recorded it. This theoretically ideal colour system was modified by various later workers, but no significant use was made of it. The prismatic microdispersion process, like the Lippmann method, suffered from the problem of long exposures, since the plate had to have very high resolving power.

So, the long-hoped-for fully practical method of direct colour photography has never been found; instead, successful colour photographs have been produced by indirect methods of analysing and reproducing colour. The principal lines of development are dealt with chronologically within each chapter in the following pages.

Above In Lanchester's prismatic micro-dispersion process, the camera lens A produces an image on the very fine grating B, with 300 opaque lines to the inch. Rays of light passed through the grating, and through the large field lens C into a second lens D containing a shallow prism E. Each ray was split into a minute spectrum which fell on the sensitive plate F. The amount of the spectrum recorded at each point was determined by the colour of the original subject. The same optical system, in reverse, was used to view the processed and printed plate, illuminated from behind and viewed through the camera lens

Below The Penrose plate holder for the Lippman process, 1899. Mercury was introduced through the upper pipe fitting, and was drained from the lower

26

Far left *Tinted photographic postcard, c. 1905. Such photographs, mass printed on bromide paper, were usually coloured by tinting through stencils cut out for each colour (87 × 135 mm)*

Centre left *Coloured portrait on sepia toned bromide paper, c. 1925. An example of good quality commercial hand colouring, the work of E. Allone, The Studio, St Neots, Huntingdon (100 × 145 mm)*

Below left '*Joe's Ship', a hand-coloured lantern slide by Graystone Bird, of Bath, Somerset, c. 1900. Graystone Bird was probably England's leading lantern slide maker at the beginning of this century (73 × 54 mm)*

Above left and right *Flexichrome prints, 1942. Dyes were applied by hand to a gelatin relief image produced from the original negative. The choice of colour was entirely that of the colourist, but the depth of colour was determined by the image (100 × 136 mm)*

Left *A Lippmann photograph, 1899, by Dr Neuhauss, who was a leading worker with this process of direct colour photography. The Lippmann process is described on pages 21 and 24 (60 × 80 mm)*

2 Colour by addition

All practical, indirect methods of colour photography are based on a theory of colour vision developed and propounded by Thomas Young in the first decade of the last century, and later elaborated by H. von Helmholtz. Young reasoned that, since all colours could be matched by an appropriate mixture of red, green and blue light, the eye must contain three kinds of receptor responding to these colours only, and therefore all other colours found in the spectrum will be seen as a mixture of those three primary sensations. For example, yellow can be produced by a mixture of red and green light, while a mixture of all three primary colours produces white light. We now know that the retina of the eye *does* contain receptors which respond to colour in this way; they are called cones, from their conical appearance when seen through the microscope. They function only in strong light conditions; other, much narrower receptors, called rods, take over in dim light, giving monochromatic vision only.

In 1855, the young Scots physicist James Clerk Maxwell discussed Young's theory, illustrating its implications with a suggestion about photography:

'Let it be required to ascertain the colours of a landscape by means of impressions taken on a preparation equally sensitive to rays of every colour. Let a plate of red glass be placed before the camera, and an impression taken. The positive of this will be transparent wherever the red light has been abundant in the landscape, and opaque where it has been wanting. Let it now be put in a magic lantern along with the red glass, and a red picture will be thrown on the screen. Let this operation be repeated with a green and a violet glass, and by means of three magic lanterns let the three images be superimposed

on the screen. The colour at any point on the screen will then depend on that of the corresponding point on the landscape and . . . a complete copy of the landscape . . . will be thrown on the screen.'

In this statement Maxwell laid down the fundamental theory behind all subsequent systems of indirect colour photography. On May 17, 1861, at the Royal Institution in London, Maxwell lectured 'On the Theory of Three Primary Colours'. After outlining the consequences of Young's theory – that there are three primary colours, and that every colour is either a primary colour or a mixture of primary colours – he demonstrated with three lanterns fitted with glass troughs containing coloured liquids that mixtures of red, green and blue light do indeed reproduce the other colours. Then came a most important demonstration.

'Three photographs of a coloured riband, taken through the three coloured solutions respectively, were introduced into the camera, [the lantern is meant here] giving images representing the red, the green and the blue parts separately, as they would be seen by each of Young's three sets of nerves separately. When these were superposed, a coloured image of the riband was seen, which, if the red and green images had been as fully photographed as the blue, would have been a truly coloured image of the riband. By finding photographic materials more sensitive to the less refrangible rays, the representation of the colours of objects might be greatly improved.'

So, the first colour photograph was shown. The photographs had been made for Maxwell by Thomas Sutton, Editor of *Photographic Notes*, who described in his journal how they had been taken.

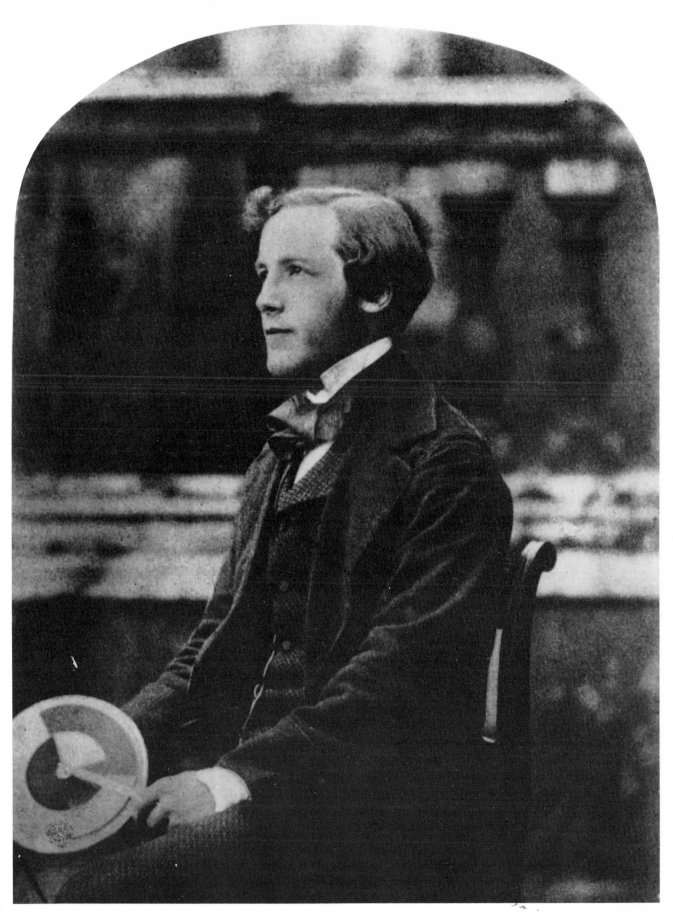

James Clerk Maxwell, who, at the age of 24, established the theoretical basis of colour photography

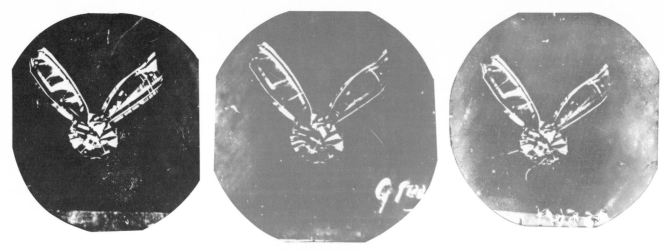

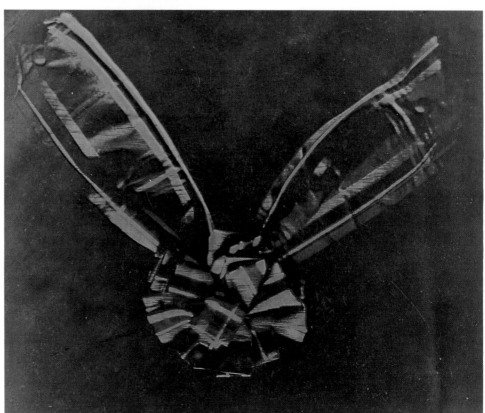

Top *In 1861 James Clerk Maxwell had prepared three
lantern slides of a striped ribbon, photographed through red,
green and blue filters. The three positive transparencies, placed
in three magic lanterns, were projected through the same red,
green and blue filters. When the three images were carefully
superimposed* above *they combined to produce a recognisable
reproduction in colour of the original. It was the first colour
photograph.*

Above right *An Ives Kromogram, c. 1897, photographed
directly through the Kromskop viewer designed to combine the
separate red, green and blue components into a single full-
colour image.*

Right *An Ives projection photochromoscope picture, 1892,
reproduced in a Kodak Dye Transfer print made from the
original projection positives.*

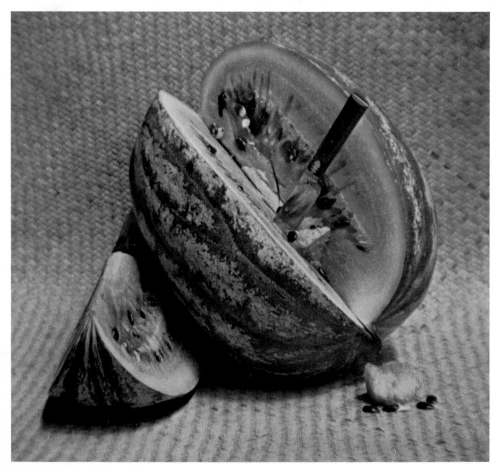

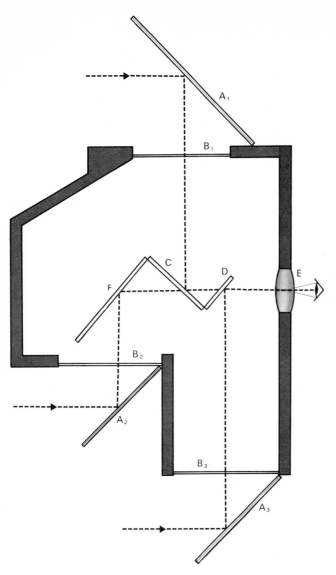

Above *In Ducos du Hauron's proposed colour viewer of 1862, light entered it reflected from mirrors A1, A2, A3, through the positives B1, B2, B3. Picture B1 was reflected from the transparent reflector C, through the transparent reflector D to the viewing lens. Picture B2 was reflected from the mirror F, through C and D to the lens. Picture B3 was observed by reflection from reflector D. Thus, all three pictures were combined at the viewing lens*

Right *Louis Ducos du Hauron, who in his writings anticipated almost all of the practical methods of colour photography*

He used liquid colour filters: a solution of ammoniacal copper sulphate 'which chemists use for the blue solution in the bottles of their windows', a solution of copper chloride for the green and a strong solution of iron sulphocyanide for the red. A fourth exposure was made through a lemon coloured glass, but was not used by Maxwell for the demonstration. The negatives were made by the wet collodion process, and the blue exposure was made in six seconds, about double what would have been needed without the filter. On the other hand, after twelve *minutes* no trace of an image of the coloured ribbon was found on the plate exposed through the green filter, and in the end the solution had to be much diluted, to a pale green, and 'a tolerable negative was eventually obtained in twelve minutes'. Eight minutes was enough to record an image through the red filter. In theory, no record at all should have been possible through the red and green filters, since the wet plate was sensitive only to blue light, yet when the negatives were printed 'by the Tannin process upon glass', and the positive projected on the screen with the same filters, 'a sort of photograph of the striped ribbon was produced in the natural colours'. In 1961, Ralph M. Evans, of the American Kodak Research Laboratory, examined the characteristics of the filters used by Sutton, and he found that the red liquid filter transmitted ultra violet radiation, to which the wet plate was sensitive. By an extraordinary coincidence, many red dyestuffs also reflect ultra violet radiation, and so the plate 'saw' the red portions of the ribbon by invisible radiation which recorded upon the sensitive coating as if it had been responsive to red light.

The principle established by Maxwell's classic experiment was that of additive colour photography. Starting with a blank screen he added together red, green and blue images to reproduce the original colours. A year later, in 1862, a young Frenchman, Louis Ducos du Hauron, sent a communication to a friend, M. Lelut, asking him to place it before the Académie des Sciences. In his paper, which was never presented, Ducos du Hauron described several proposed methods for producing colour photographs using a combination of three colours, red, yellow and blue. He described a 'Chromoscope' in which by means of three transparent reflectors he proposed to combine the three images produced from the three colour exposures. Although his choice of colours was wrong, based on earlier, erroneous theories of the primary colours, the principle of his viewer was essentially that used many years later in

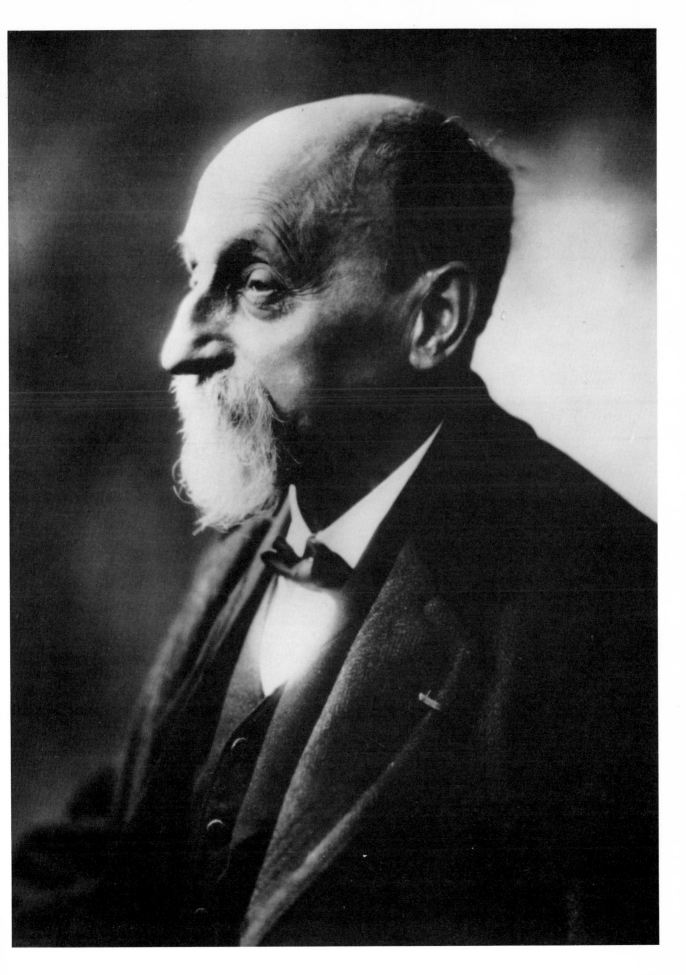

Above *A negative plate, exposed in a stereoscopic photo-chromoscopic camera, c. 1900*

Right *In Ives' Kromskop, 1895, the red, green and blue separation positive transparencies were laid over the 'steps' of the viewer. The surface of the cyan glass reflector A reflected the red image, seen through the red filter B, to the viewing lens. The blue picture, seen through the blue filter C, was reflected from the surface of the green glass reflector D, through the cyan reflector A, to the viewing lens. The green image was seen directly, through the reflectors A and D. When the viewer was accurately adjusted, the three images in register combined to give a full colour image. The mirror E was used to illuminate the green picture equally with the blue and red pictures*

Far right *A stereoscopic Kromogram, exposed in April 1901. The three positives were joined by tapes in the correct viewing relationship. An Ives' Kromogram is reproduced in colour on page 31*

commercial additive colour processes. He published details of another, simpler design in 1869, this time using the correct primaries, red, green and blue. In the same year, another Frenchman, Charles Cros, published theoretical proposals for several colour processes, including the principle of a viewer using reflectors to combine the three component images, but, like Ducos du Hauron, mistakenly suggested red, yellow and blue as the primaries. Later, in 1879, he published details of a practical design of a 'Chromometre' – a device for measuring and analysing colours by mixing red, green and blue light, but also suitable for adaptation to view sets of three positive transparencies made from negatives exposed through red, green and violet filters.

These early suggestions of Ducos du Hauron, Cros and others were of very limited practical value, since the photo-sensitive materials available at the time would respond only to blue light. Practical application had to wait until the introduction of methods for making photographic materials sensitive to the whole spectrum of colours. Dr H. W. Vogel discovered in 1873 that dyes added to photographic materials extended their sensitivity to colours other than blue. In 1882 commercial dry plates sensitive to blue *and* green light were produced, and these isochromatic, or orthochromatic, plates soon came into general use. Because they were still much more sensitive to blue than to green, they were normally exposed through a yellow filter to balance up the exposure. In 1884 Dr Vogel discovered a method of sensitising plates to orange as well as green light, but full sensitivity to red light did not come until the discovery of new sensitising dyes in the early years of this century,

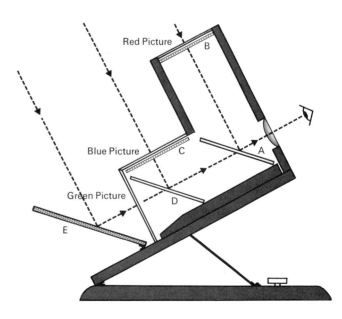

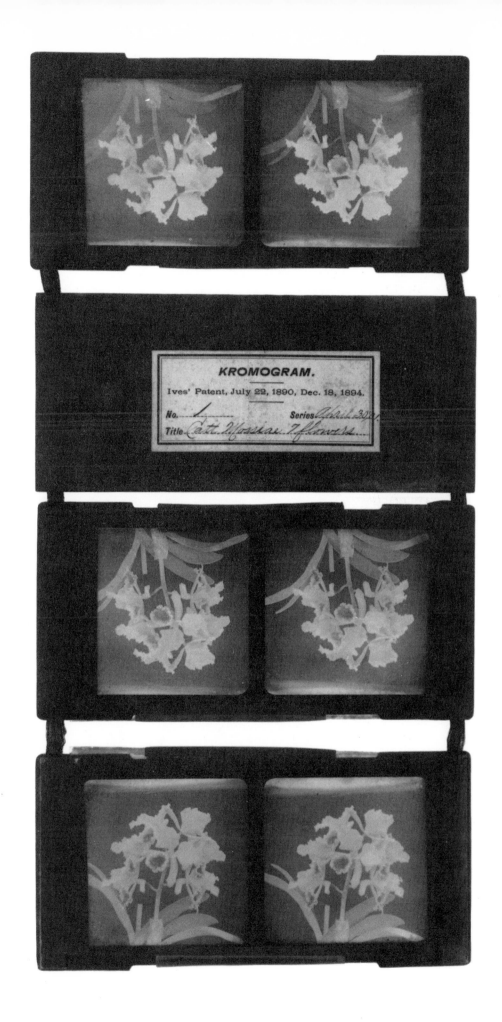

KROMOGRAM.

Ives' Patent, July 22, 1890, Dec. 18, 1894.

No. 1 Series April 30th

Title Catt. Mossiae 7 flowers

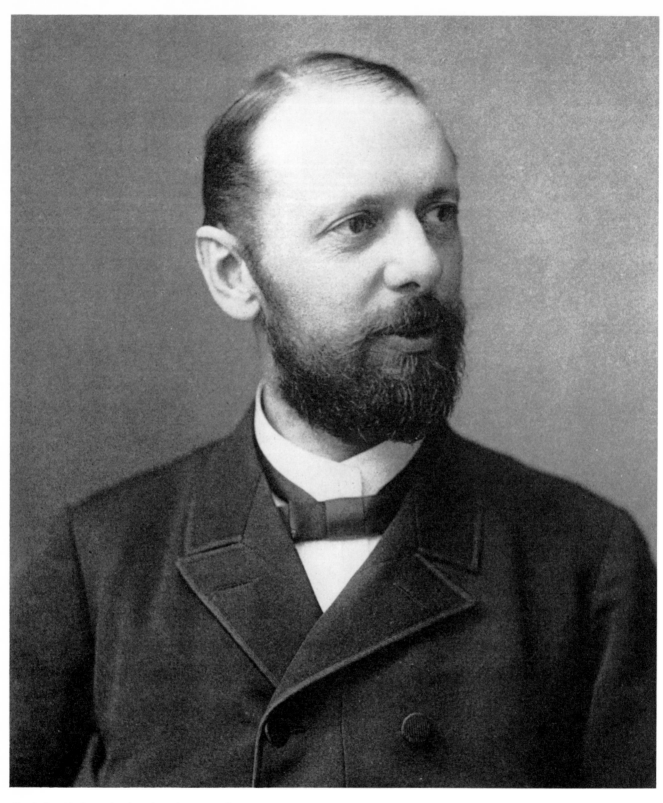

*Frederick E. Ives, the American inventor of many
practical colour processes*

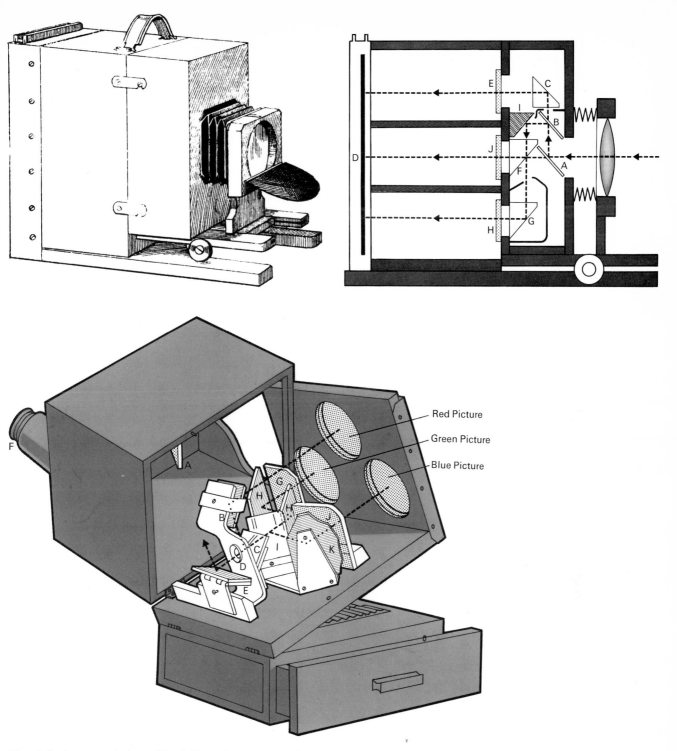

Red Picture

Green Picture

Blue Picture

Top left *An external view of Ives' Kromskop camera, 1895*

Top right *In Ives' camera, a system of mirrors, transparent reflectors and prisms split the light from the lens into three. One light path went from the surface of transparent reflector A, through reflector B and prism C to the plate D, via a filter E. A second path went through reflector A from the surface of prism E, then through prism G and filter H to the plate. The third path was from the surface of A, then from the surface of reflector B to the mirror I and thence through the prism F and filter J to the plate. The convoluted path of the three beams was necessary to equalise the length of the optical paths, so that all three images were the same size*

Above *In Ives' early Chromoscope, 1892, the slide with three separation positives was fitted in grooves at the front. Light from the red exposure passed through the red filter A (brought into position when the lid was closed) and was reflected from the mirror B to the transparent reflector C. It then passed through the lens D, on to the mirror E and thence to the eyepiece F. Light from the green positive passed through the green filter G, was reflected via the mirror H, through the transparent reflector I then, via C, D and E to the eyepiece. The blue picture reached the eyepiece through the filter J, the mirror K and then to the reflector I from which it went with the red and green images through the mirror and lens system C, D and E*

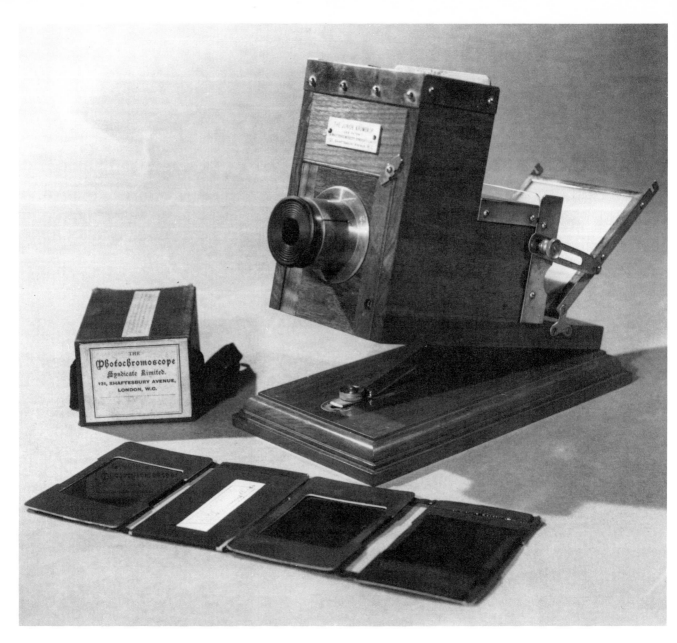

The Ives' Junior Kromskop viewer, 1895, was constructed to the same principle as the stereoscopic model, but took a set of single pictures

and the first fully panchromatic plates, sensitive equally to all colours, were sold by Wratten and Wainwright of London in 1906.

The first commercial application of the additive process was the work of an American, Frederic E. Ives, a prolific inventor of colour photographic processes throughout his life. In 1888, at the Franklin Institute of Philadelphia, Ives read a paper on 'Helichromy' in which he announced a process for making colour prints from three colour separation negatives exposed through red, green and blue filters, and showed several examples. This process we shall consider in Chapter Four. Ives soon discontinued his attempts to develop a colour printing system, and instead concentrated on the design of additive viewing devices. In a series of patents taken out between 1890 and 1897 he outlined a variety of methods of viewing or projecting colour pictures. His first demonstrations, in 1892 and 1893, used viewing devices with an internal system of reflectors, rather like Ducos du Hauron's early 'chromoscope', to combine three circular separation images on a single plate into one, full colour image. In 1895 Ives demonstrated his improved 'photochromoscope' system. His camera contained a system of two transparent and four silvered reflectors, splitting the light from the lens into three beams, forming three images on a single $7 \times 5\frac{1}{2}$-inch plate. By using an external mirror system, stereoscopic pairs of colour separations could be taken with the same camera. The negatives were printed on glass as transparencies, and viewed on the photochromoscope, which Ives described in 1896:

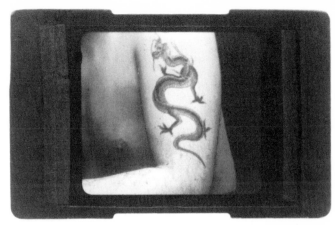

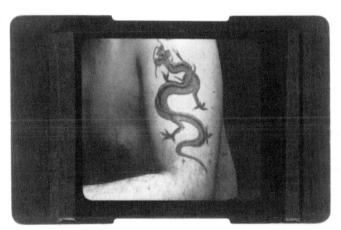

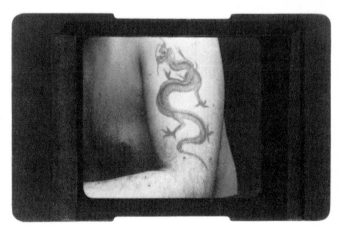

A Junior Kromogram of a dragon tattoo, 1899

'The form of the photochromoscope suggests steps of stairs. It was first made with three steps, and on the top of each step was placed one image of the chromogram, which is made in sections hinged together so as to fold up. The model was afterwards reduced in size, and made more powerful, by having only two steps, the third image standing upright against the front of the lower step. The red image, lying horizontally on the top step, is seen by reflection from the first surface of a transparent mirror of cyan-blue glass, which stands underneath it and in front of the eye, inclined at an angle of 45 degrees. The blue-violet image lies upon the second step and is seen (through the cyan-blue glass abovementioned) by reflection from the first surface of a transparent mirror of green or yellow glass, which is also inclined at an angle of 45 degs. under the image. The green image, standing upright against the lower step, is viewed directly through the cyan-blue and green (or yellow) transparent mirrors, both of which

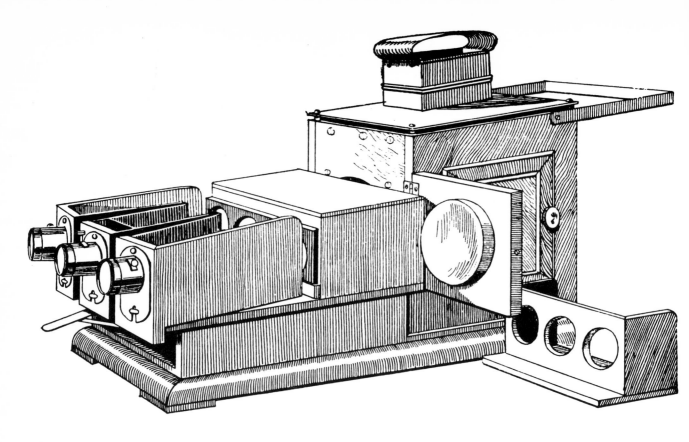

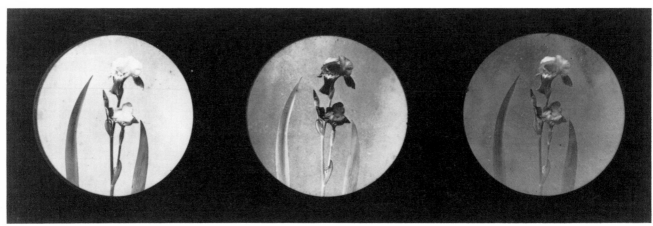

Top *The Ives' Lantern Kromskop, 1895, adapted the magic lantern to project three separation positives through three lenses and filters into superimposition on the screen*

Above *A Lantern Kromskop slide of an iris, 1895*

transmit the green light. By this means, the three images are so blended as to appear as one to the eye.'

Ives' apparatus was sold commercially under the name Kromskop from 1895, and a whole range of models and accessories was supplied. The Kromskop stereoscopic viewer cost £5, and Kromograms of a wide range of subjects could be purchased at 5s each. A gas lamp to illuminate the viewer evenly at night cost two guineas. The Junior Kromskop, for single pictures only, cost £3 10s and the Kromograms 3s 6d. The Lantern Kromskop was an adaptor for the magic lantern, enabling Kromograms in slide form to be shown on a screen, through three lenses and filters. With six slides and a case, it cost ten guineas. For those who wished to make their own Kromograms, 'multiple backs' were supplied at prices from £3 10s to £4 10s. These were repeating backs, fitted to an ordinary plate camera, and permitting three separation negatives to be taken in quick succession by sliding along the plate and filter holder after each exposure. The Kromskop camera, used for making the commercial Kromograms, was an improvement on Ives' original design, using prisms as well as mirrors to split the beam of light from the lens three ways inside the camera. The exposures required one minute or more for well-lit landscapes. Ives also devised a repeating back camera which made the three exposures on one plate in quick succession, driven by a spring motor which allowed any desired ratio of exposure to be given to the three images, in a total time ranging from fifteen seconds to three minutes. It was designed for use in the studio. The commercial Kromograms were joined by tapes in the correct order. The red record was at the top; next came an opaque title card, then the blue record and finally the green record at the bottom. The Kromogram was laid on the steps of the Kromskop, which had been set up previously by adjusting its overall position with a hinged mirror reflector at the rear, so as to give a uniform white field seen through the viewing lenses. If the lighting falling on the viewer was uneven, a ground glass screen was provided to lay over the three viewing positions to diffuse the light. Preset screw adjustments were provided to re-align the internal reflectors if they became displaced.

In London, the Kromskop company, the Photochromoscope Syndicate, appointed W. Watson and Sons as their agents in 1898, with the London Stereoscopic Company having the franchise for the West End. The lantern attachments were supplied through Newton and

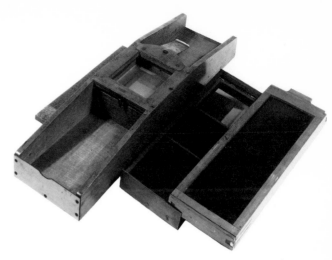

Ives' repeating back, 1895, adapted an ordinary plate camera for colour work. The plate was carried in its holder (right), placed behind a frame carrying the three colour filters (centre). The two could be moved together past the exposing aperture in the back (left) which was attached to the camera. Three exposures could be made in quick succession

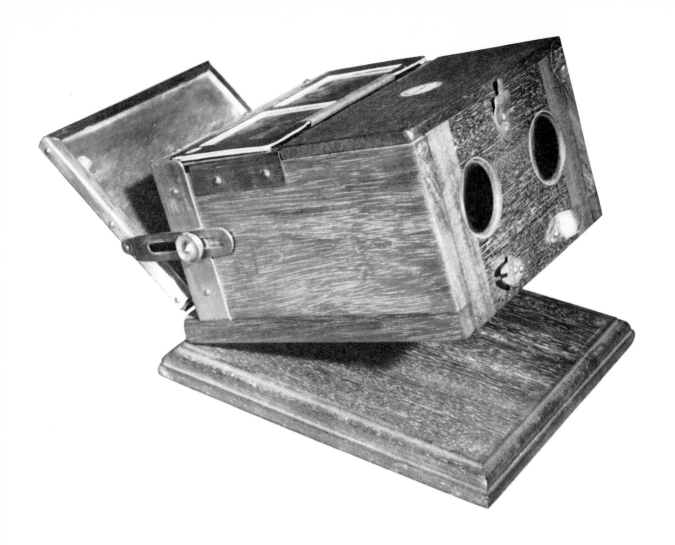

Above *The Kromaz viewer, 1899, combined two pairs of stereoscopic images to give a full-colour picture. (The hood which surrounded the lenses has been removed in this photograph)*

Right *An advertisement for the Kromaz system, 1899*

Company. The Kromskop was promoted as being 'invaluable for Evening Parties, At Homes, Conversaziones, Garden Parties &c, &c, and is the most beautiful invention of the nineteenth century'. The London *Daily News* reported in April 1896:

> 'At present the system is perfected for "still life", and when a little further developed will, it is expected, be equally available for perpetuating living originals . . . When the Kromskop arrives at this point of accomplishment, then bid farewell to the minor poet; his lady-love will no longer live in dreams, for he will preserve in a box the very sheen of her hair . . .'.

However, this hoped-for development of the Kromskop did not come, and within a few years it passed out of favour, as less complicated, more readily viewed colour systems appeared.

A few rivals to the Kromskop were introduced by other makers in the late 1890s, but none enjoyed the same success. However, one is worth noting for its unusual construction. The Kromaz system, patented in England by C. S. Lumley, T. K.

COLOUR PHOTOGRAPHY FOR ALL
New and Simplified Process.
(BARNARD AND GWENLOCK'S PATENTS.)
KROMAZ.

LOW PRICE. **PERFECT RESULTS.**

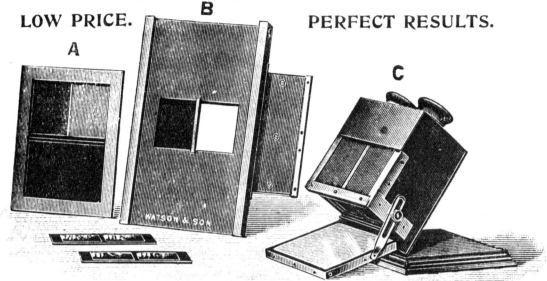

THE simplicity of this Process, and the small cost of the necessary Apparatus, combined with the beautiful results to be obtained, should make it essential to every Photographer.

The Apparatus required consists of A, frame containing the set of colour screens through which exposures are made; B, the attachment which fits into the back of Camera, and carries the colour screens and dark slide when making exposures; C, the chromo stereoscope, in which pictures are viewed to obtain the colour effects.

The Process can be worked on either ¼-plate or ½-plate Cameras, in which the focusing adjustment is done from the front. In the smaller size 4 exposures are necessary; in the larger size only two exposures are required. The whole of the exposures are made upon a ½-plate, either one at a time or in pairs. The pairs of images may be made with a pair of Lenses, or with one Lens, in conjunction with the Kromaz Mirrors.

The method of procedure is to take 2 pairs of images,—1 pair through red and blue screens, and 1 pair through green screens. From the 2 stereoscopic negatives, positives are made, which when viewed in the Chromo Stereoscope reveal the natural colours of the objects photographed with absolute fidelity.

Full instructions are given with each set.

PRICE LIST.

	£	s.	d.
Kromaz Repeating Holder or Multiple Back, with set of Colour Screens for taking purposes	2	2	0
Half-plate Dark Slide fitted to the above	1	0	0
Kromaz Stereoscope for viewing Objects in their natural colours	2	10	0
Set of Mirrors, enabling two stereoscopic images to be taken on a plate, using only one Lens	0	12	6
Cabinet to contain Kromaz and twelve sets of views	0	10	6
Kromaz views	0	3	6

The above prices are net for Cash.

May be obtained of all Dealers in Photographic Apparatus, or of

W. WATSON & SONS,
313, HIGH HOLBORN, LONDON; and
16, FORREST ROAD, EDINBURGH.

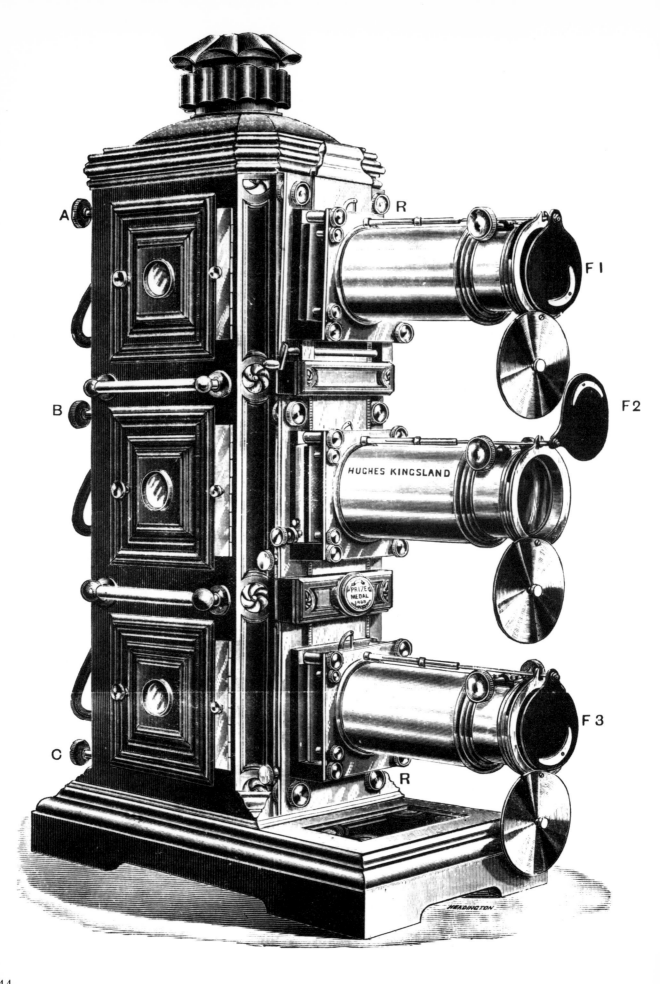

Barnard and F. Gowenlock in 1899, used a camera with a repeating back to produce two stereopairs on one plate. The first exposure was through red and blue filters side by side, each half of the stereo pair being exposed through a different filter. The second exposure, after the darkslide had been moved down in the repeating back, exposed both stereo images through a green filter. The developed negatives were printed as glass positives, and these were mounted in a hinged mount. The Kromaz viewer was similar in construction to Ives' Kromskop, but had only one step. The red and blue exposed stereo pair were placed horizontally on the top of the instrument, and the green pair were placed vertically at the back, each pair being placed over filters of the appropriate colours. A single internal reflector combined the red and green right eye images and the red and blue left eye images to give a full colour picture. This method was interesting in that the addition of red and blue images took place in the viewer's brain, rather than by external superimposition, as in the Kromskop.

A rather complex method of additively viewing colour separations was developed and patented by Professor R. W. Wood in 1899. He produced in the usual way three positive transparencies from three separation negatives. The positives were in turn printed in very accurate registration on to a single plate coated with bichromated gelatin (see Chapter Four) through three diffraction gratings of 2,000, 2,400 and 2,750 lines per inch. (Diffraction gratings consist of equally spaced, finely ruled lines produced with great precision. Gratings with rulings of 2,000, 2,400 and 2,750 lines to the inch diffract to the same point red, green and blue light respectively, if superimposed.) Thus, after the plate had been 'developed' by washing it in warm water to remove the unhardened gelatin, it carried three superimposed separation positives each of which was reproduced as a fine line image which diffracted either red, green or blue light. The apparently completely transparent plate gave an image in full colour when observed behind a large convex lens in a special viewer in which the three diffracted colour images were combined at a slotted eyepiece. A near line source of light was desirable for successful results. Because of the complexity of the printing process, and the cost of acquiring accurate diffraction gratings, Professor Wood's process saw little use, and it was regared as an intriguing scientific novelty rather than a practical colour process.

For those possessing a triple, or triunial, magic lantern, colour photographs could be projected on

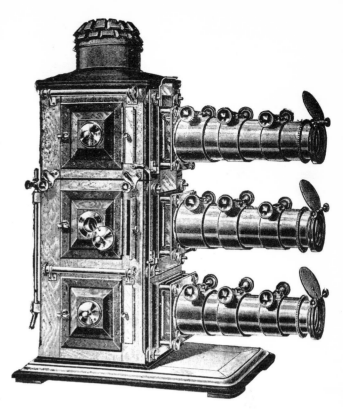

Triple, or triunial, lanterns were used by some workers to project colour photographs. Separation positives in the form of lantern slides were placed in the three sections of the lantern. These are examples of two popular triple lanterns of the 1890s. Left *Hughes' 'Dowcra'.* Above *Lancaster's Triple*

the screen, using Maxwell's original method. Triple lanterns were in effect three lanterns arranged one on top of the other, with three separate light sources. In use during the last half of the last century, they enabled the lanternist to present complex effects of 'dissolving views', where one slide slowly blended into the next, and superimpositions. If three separation negatives were made, and printed as lantern slides, they could be projected through the three lenses of the lantern in superimposition on the screen, using colour filters of the appropriate kind to colour the light. Such apparatus was cumbersome and costly, and its use was mainly confined to scientific demonstrations of the principles of colour photography. In the early years of the new century interest waned in the production of colour photographs which used optical devices for viewing the results, with the arrival of new methods in which the colour filters for taking and viewing the results were incorporated in the single photographic plate.

3 Dots and lines

Photography in Natural Colours.

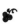

Above *An advertisement for Professor Joly's colour line screen process, 1899*

Right *Auguste and Louis Lumière, the inventors of the Autochrome process*

The original idea for a colour process based on incorporating minute colour filters in the sensitive material belongs, like so many other notions in colour photography, to Ducos du Hauron. In a French patent of 1868, and in his book *Les Couleurs en Photographie*, published in 1869, Ducos du Hauron proposed a screen made up of fine lines of three colours – red, yellow and blue – which when viewed from a distance could not be resolved individually, and which blended in the eye to give a uniform grey appearance. By selectively blocking the lines of the screen any colour could be produced. For example, blocking the yellow lines would allow only red and blue light to pass through, giving purple, while covering the yellow and red lines would allow only blue to pass through. He did not put his theory into practice, and his choice of yellow instead of green would not have made a satisfactory result. However, a quarter of a century later his principle was brought into practice. In 1894 Professor John Joly of Dublin patented a process for producing a screen of red, green and blue-violet lines by ruling them on a gelatin-coated glass plate. Joly used ruling machines of great accuracy, with drawing pens trailed across the plate producing lines less than 1/225 inch (0.1 mm) wide, in contact with each other, but not overlapping. Aniline dyes mixed with gum provided the colour inks. The ruled plates were varnished when they were dry. The screen plate was placed face to face with an orthochromatic plate in a plate holder, with the screen towards the lens. It was necessary to use a yellow filter over the camera lens, to correct the plate's excessive blue sensitivity. The exposed plate was separated from the screen and developed. A black and white transparency was then made on a

The Autochrome plates were introduced in 1907

suitable plate, and this positive was bound up with another line screen, the two being very carefully registered so that the correct colour element was behind each line of the picture. The Joly process was introduced commercially in 1895, and was the first additive screen-plate process to appear on the market. It remained available for a few years, but the inadequate colour sensitivity of the negative plates then available limited its usefulness.

A very similar system was developed almost simultaneously by James McDonough of Chicago and was patented by him in 1896. He ruled red, green and blue lines about 1/200 inch (0.13 mm) wide on mica sheets in his early experiments, mounting them on glass sheets for use in the camera, as with Joly's screen plates. His results were reported as being 'in general . . . very beautiful'. McDonough's process was exploited commercially by the International Colour Photo Company of Chicago, who refined the ruling instruments. By drawing the glass plates over the ruling pens, the company achieved very fine screens of 300 lines to the inch (0.08 mm wide), and even finer, but the failure rate was high, with an enormous percentage of faulty plates. The process

was available commercially in 1897, for a short time. It achieved no commercial success, as a machine could rule only about three 30 × 24 inch (76.2 × 61 cm) screens in a day, and the screens, at 8s for a dozen quarter-plates, were sold below cost. The company is said to have spent nearly $500,000 in attempts to overcome production problems.

In an earlier patent of 1892, McDonough had suggested another method of making a three-colour screen. He proposed to dye three lots of shellac red, green and blue, and then grind them to a very fine powder. The three coloured powders could then be mixed to give a neutral grey mixture. This mixture of dyed shellac McDonough proposed to dust on to a glass plate with a tacky surface to which it would adhere. The screen so formed, of a random distribution of red, green and blue particles, could be coated with a photographic emulsion, exposed through the screen in the camera. No commercial application was made of McDonough's idea at the time, but in 1904 the brothers Lumière announced that they had devised a similar process using dyed potato starch grains:

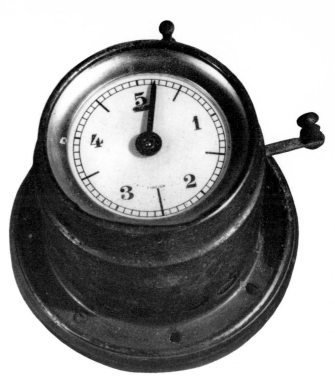

This timer was designed especially for the timing of the processing of Autochrome plates. It was sold in England under the Ensign trademark in 1908

'We first separate in potato starch and by the aid of apparatus made for this purpose, the grains having a diameter of from the fifteenth to the twentieth thousandth part of a millimetre. These grains are divided into three parts and coloured respectively red-orange, green and violet . . . The coloured powders so obtained are mixed, after complete dessication, in such proportions that the mixture shows no dominant tint. The resulting powder is spread by a brush on a sheet of glass covered with an adherent or sticky coating. With suitable precautions we obtain a single coating of grains all touching and without superposition. We then stop by the same process of powdering the spaces which may exist between the grains and which would allow the passage of white light. This stopping is accomplished by the use of a very fine black powder, as, for example, charcoal. We have by these methods formed a screen in which each square millimetre of surface represents two or three thousand small elementary screens of orange, green and violet.'

After varnishing the screen, and coating it with a panchromatic emulsion, the plate could be placed in the camera.

'Exposure is made in the ordinary manner, . . . taking the precaution always to turn the glass side of the plate to the lens in order that the light may pass through the colour particles before reaching the sensitive emulsion. The necessity of employing emulsions of an extremely fine grain, and in consequence, of lower speed, and the interposition of

Photomicrographs of a
selection of colour screen
plates. A–L are magnified
45 times; M–P are
magnified 150 times

A *Joly, 1895 (page 46)*
B *Warner-Powrie, 1907
(page 53)*
C *Krayn line, 1907
(page 56)*
D *Krayn mosaic, 1907
(page 56)*
E *Dufay Dioptichrome,
1909 (page 57)*
F *Omnicolore, 1907
(page 56)*
G *Thames, 1908 (page 57)*
H *Paget, 1913 (page 61)*
I *Leto, 1913 (page 64)*
J *Baker Duplex, 1926
(page 68)*
K *Finlay, 1929 (page 68)*
L *Dufaycolor film, 1935
(page 72)*
M *Autochrome, 1907
(page 49)*
N *Agfa Colour, 1916
(page 64)*
O *Lignose film, 1926
(page 68)*
P *Aurora, 1909 (page 60)*

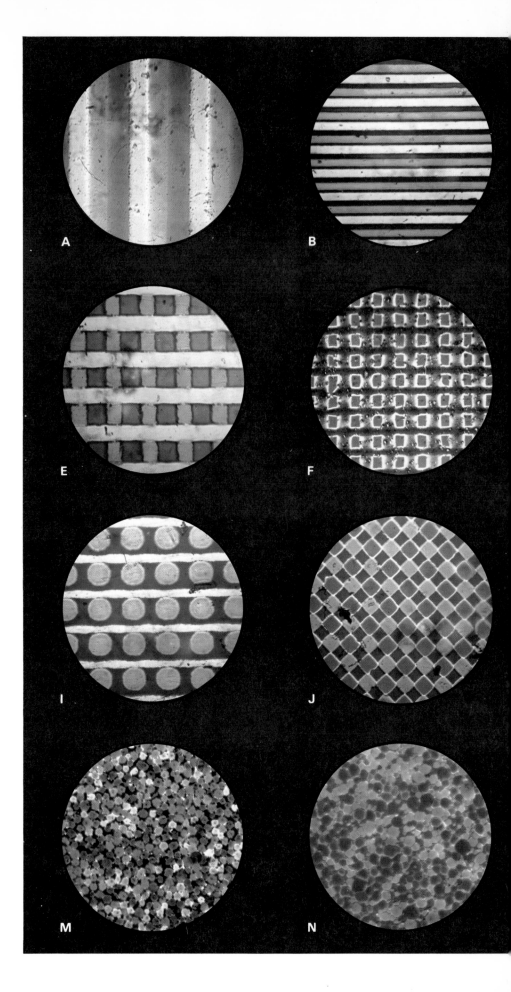

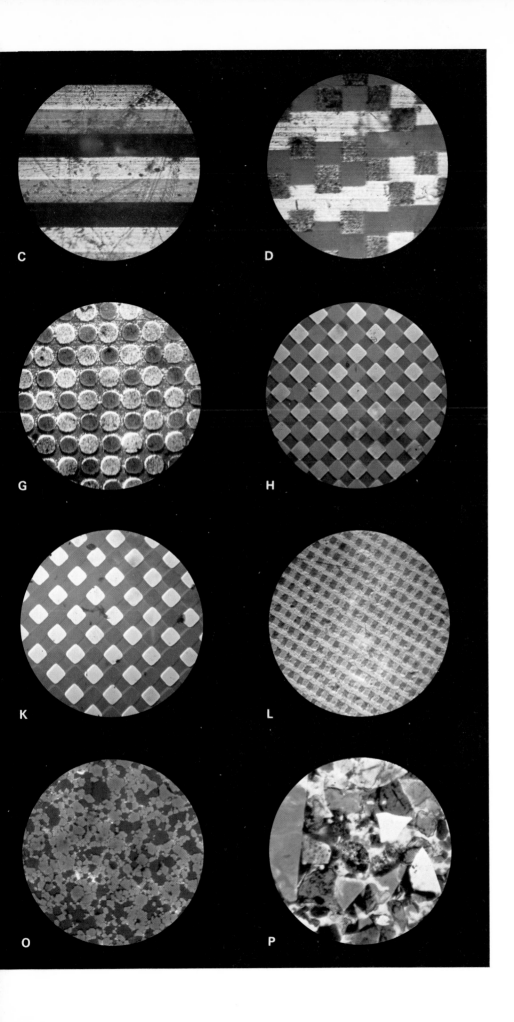

C

D

G

H

K

L

O

P

Watkins Colour Plate Meter, 1909, was a version of the popular Bee meter, calibrated for Autochrome plates

a coating formed of a system of microscopic screens, render the necessary exposure longer than for ordinary photography. . . . If it is desired to obtain correct colours we must, after development, but without fixing the image, procede to reverse it by dissolving the reduced silver, and then by a second development reduce the silver which was primarily acted on by the light.'

After overcoming various production problems the Lumières launched their new Autochrome plates in the summer of 1907. They were immediately successful. The *British Journal of Photography* reported in July, 'The demand in France has been so great that there has been no chance of any plates reaching England yet, but as the makers are doubling their output every three weeks it will not be long before the plates can be obtained commercially in England'. In September they were able to report, 'A few weeks ago, even in France . . . it was almost impossible to get an adequate supply . . . but . . . the disparity between demand and supply appears to have been removed'. The Royal Photographic Society awarded the Autochrome plates a medal in the Technical section of the 1907 Exhibition, and the Lumière brothers received the Society's Progress medal in 1909.

The Autochrome process was the first fully practical single-plate colour process to reach the photographic public. It was easy to use. The plate was loaded into a conventional holder, glass to the front. The exposure was made through a yellow filter which corrected for the excessive blue sensitivity of the emulsion. A normal exposure for a landscape in summer, by midday sun, was one to two seconds at f/8, while a typical portrait exposure in a well lit studio would be ten to thirty seconds at f/5. The exposed plate was developed to a negative, and after a rinse the silver formed was bleached in an acid potassium permanganate solution. After another rinse the plate was redeveloped in the light to produce a positive. Fixing and washing completed the operation, although the dried plate was usually varnished for protection.

The Autochrome plate could record both saturated and subtle colours with fidelity, and since the screen and the image were combined, there were no registration problems. Nonetheless, it had drawbacks. The exposure times were long, and the processed plates were very dense, transmitting only $7\frac{1}{2}\%$ of the light reaching them. Although the starch grain filters were microscopically small – about four million to the square inch (620,000 to the square cm) – their random

distribution meant that inevitably there would be clumping – groups of grains of the same colour. Probability theory predicted that in a square inch (6.5 square cm) there would be thirty-three clumps of twelve grains or more. In practice about fifty of such clumps were present in each square inch, and were visible to the naked eye. A further drawback was the cost. A leading English colour photographer, J. C. Warburg, was moved in April 1909 to protest in a letter to the *British Journal of Photography*:

'One sometimes wonders why such a beautiful process as the Autochrome is not more practised in England, and one is driven to the conclusion that the price of the plates has a good deal to do with the matter . . . I feel it something of a public duty to protest against the enormous difference in price charged by the sole agents of the Lumière Co. in England and the price charged by every dealer in France. While the French price for $6\frac{1}{2} \times 4\frac{3}{4}$ in. plates . . . was 9 francs (7s $2\frac{1}{2}$d) per box, we were being charged here 10s a box. . . . Half a dozen boxes of half-plates bought in France at the end of March cost me 34 fr. 80c., or, if one were to add the cost of postage to England (at 1fr. 35c.), 36 fr. 15c., say 29s. Half a dozen boxes of the same batch were being charged here at that date at 60s, just over double. One does not grudge Messrs. Lumière a substantial reward for their years of experiment, culminating in a brilliant invention, but the importers stand on a very different footing, and by their excessive charges are actually preventing the use of plates.'

Warburg's letter coincided with a reduction in the price of Autochrome plates in England; a box of four quarter-plates then cost 4s, compared with about 1s 9d for twelve ordinary panchromatic plates of the same size. The Autochrome plates were available in most popular sizes from $3\frac{1}{4}$ inches square (8.25 cm) to $8\frac{1}{2} \times 6\frac{1}{2}$ inches (21.6 × 16.5 cm), and in various metric sizes from 9 × 12 cm to 18 × 24 cm, as well as in the popular stereoscopic size of 4.5 × 10.7 cm. The Autochrome plates remained on the market until the 1930s.

Several new screen-plate processes were also first demonstrated in 1907. John H. Powrie had patented in 1905 a method of producing a line screen by photographically printing through a black line screen of the type used by printers, on to a plate coated with gelatin or fish glue made sensitive to light by treating it with potassium bichromate. Such coatings harden when exposed to light, and could be printed and stained in a series of operations so as to give a fine line screen of red, green and blue elements. Powrie and his

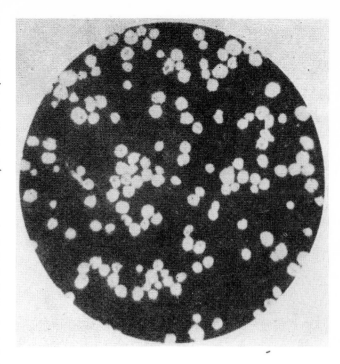

'Clumping of red grains in Autochrome' – an illustration from the classic paper by C. E. K. Mees and J. H. Pledge 'On some experimental methods employed in the examination of screenplates', April 1910

Above '*Arum lily and Anthuriums*', *1898 – a Joly process lantern slide. The process is described on page 46 (70 × 70 mm)*

Right *Still life. A large Joly process plate, c. 1898 (95 × 142 mm)*

Below right '*La Vulgarisation No 24*', *a commercially produced Autochrome plate, c. 1909, sold by a Parisian company (80 × 100 mm)*

Far right '*Old Familiar Flowers*', *1919. An Autochrome plate by Mrs G. A. Barton, a well-known amateur photographer (112 × 157 mm)*

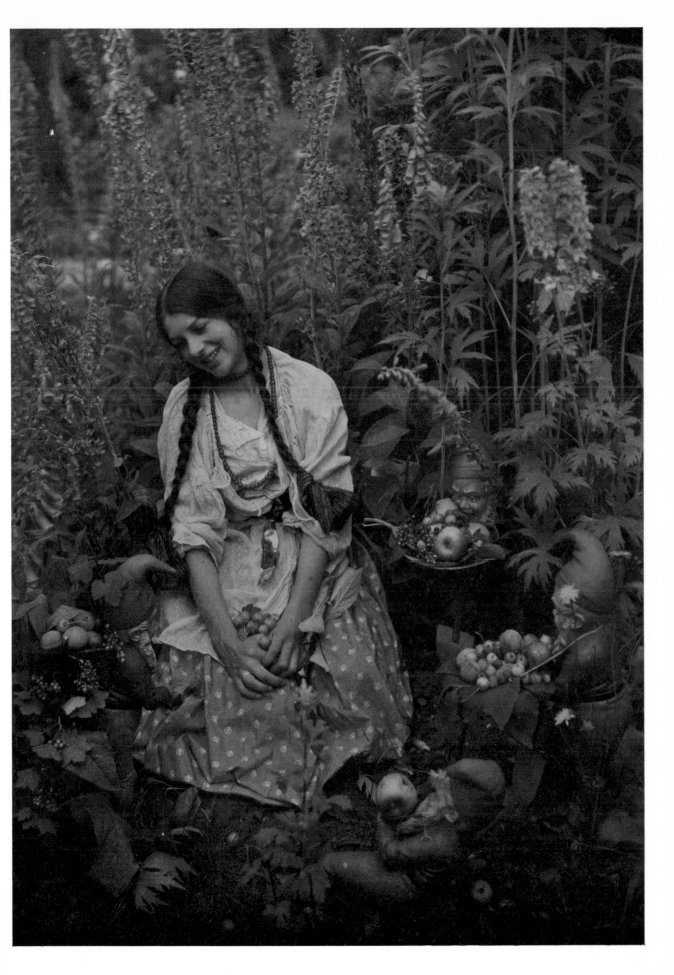

collaborator, Florence Warner, were able to produce screens with as many as 600 lines to the inch (236 to the cm), at a rate of 360 10 × 8 inch (25.4 × 20.3 cm) plates on each machine per day. The Warner-Powrie process was described in 1907, and it was proposed to issue the plates commercially under the name 'Florence Heliochromic Screen Plates'. Nothing came of the process, nor of the improved version, announced the following year, which used a fine screen of red and blue squares between green lines. Another method of producing a line screen was patented in 1904 by the German Robert Krayn, and was demonstrated by him in November 1907. Krayn stained very thin celluloid sheets red, green and blue, and cemented them interleaved to form a thick block from which thin slices were cut. Krayn was able to produce sheets of line screens up to 16 × 12 inches (40.6 × 30.5 cm) in size, with 175 colour lines to the inch (69 to the cm). Krayn's process had a very limited commercial use, and in 1908 a finer screen, of 254 lines to the inch (100 to the cm) proved no more successful, the film being very prone to split along the lines of the cementing. By recementing the

Jougla Omnicolore plates, invented by Ducos du Hauron and de Bercegerol, were sold from 1907

sliced sheets and slicing the block again, Krayn also produced a mosaic screen, but this was no improvement.

A more successful regular screen-plate process was introduced in June 1907, after a demonstration at the French Photographic Society in April. Designed by the elderly Ducos du Hauron and R. de Bercegol, the screen was made by first ruling a gelatin-coated plate with lines of greasy, transparent blue-violet ink. The spaces between these lines were then dyed yellow. Lines of greasy cyan ink were then printed at right angles, combining with the yellow lines where they crossed to form green squares. Finally, the plate was dyed with a magenta dye, which took only on the exposed yellow areas producing red squares. After varnishing, the screen was coated with a panchromatic emulsion, which was processed by reversal development to give a positive. Exposure times were typically 1/5 to 1/10 second at f/8 in midsummer sunshine. The process was named Omnicolore, and was on the market for several years, sold by Jougla et Cie. The greater sensitivity of the Omnicolore plate relative to the Lumière Autochrome was due to its imperfect filters, which had a number of holes and gaps, and which were also not very selective in their absorption of colour. Not surprisingly, the colour quality of the

Omnicolore plates was inferior to that of the Autochrome.

Two new regular screen-plate processes were introduced in 1908. C. L. Finlay's Thames Screen Plates were shown in London in the spring, and were on the market by early summer. The plates were produced by a process patented by Finlay in 1906, and carried red and green circles, 1/400 inch (0.06 mm) in diameter, almost touching, with the spaces between them coloured blue. The screen was placed in contact with a panchromatic plate for exposure in the camera, using the usual yellow correcting filter, and the plates were about eight times faster than the Autochromes, since the screen had a greatly improved light transmission – about 12% – and faster plates could be used. The exposed plate could be processed by reversal to a positive, but was usually developed to a negative and printed on a positive plate, which could then be bound up in register with a Thames viewing screen. In 1909 a 'combined' Thames plate was sold by the Thames Colour Plate Co., with the screen plate coated with emulsion. Four negative plates and two colour screens, or four combined plates, sold for 2s 6d in the quarter-plate size. Plate sizes ranged from $3\frac{1}{2} \times 2\frac{1}{2}$ inches (9×6 cm) to $8\frac{1}{2} \times 6\frac{1}{2}$ inches (21.6×16.5 cm). The Thames plates remained on the market until around 1910.

The screen plate devised by the Frenchman Louis Dufay was made by superimposing a screen of pairs of lines of complementary colours, such as magenta and green, at right angles on a screen of pairs of lines of non-complementary colour, such as cyan and yellow. The combination produced green lines with rows of red and green squares between them. Dufay claimed four colours on his screen, since the combinations of green and cyan and green and yellow produced slightly different hues, but this made no difference in practice. The screen had 150 to 200 elements to the inch (60 to 80 to the cm). The process was first named Diopticolore, when it was announced in the summer of 1908 (at that time the screen was being produced by a greasy ink printing method, like Omnicolore), but the 'four-colour' screen process was launched in Spring 1909 under the name Dioptichrome.

The screen was mounted in a nickel frame, into which the special 'Panchro-Inversable' plate was located with centring springs. The frame was fitted into the plateholder, and exposure made in the usual way through the screen. The exposed plate was processed by reversal development, and was returned to the frame for viewing. In the summer

The Thames Colour Plate process was sold first as a separate plate process in 1908 (top). From 1909, the process was available as a combined plate. A reproduction of a photograph made by the earlier process is shown on page 66

Above left *The May Queen, c. 1913. An unusually large group of children, most of whom have managed to remain still during the several seconds' exposure of the Autochrome plate* (*110 × 155 mm*)

Below left *The Motor Car – an Autochrome plate taken in 1910* (*120 × 165 mm*)

Above *The Bridge – an Autochrome plate, c. 1912. An attractively composed landscape in which the water-gatherer has had problems in keeping still during the exposure* (*96 × 70 mm*)

Left '*Burnham Beeches*', *1911. An autumnal landscape by G. H. Parker* (*120 × 160 mm*)

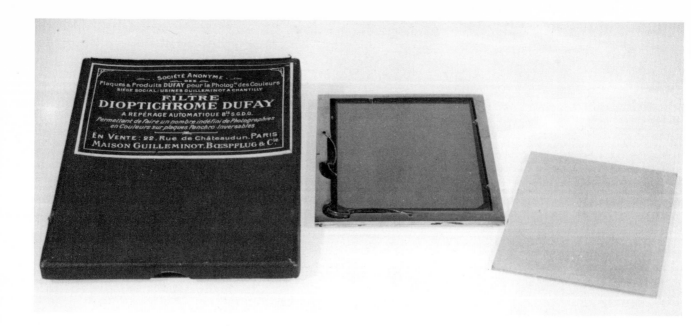

The Dufay Dioptichrome process of 1909 used a filter screen fitted in a nickel frame (centre), in which a panchromatic plate (right) was fitted for exposure. A positive transparency, made from the exposed negatives, was placed back in the frame for viewing

Right *After 1910, Dufay Dioptichrome plates were sold ready-coated with emulsion. Some of the results are shown on page 67*

of 1910, a new version with an integral screen coated with emulsion was introduced, and around 1912 the method of manufacturing the screen was changed to produce a screen with blue lines alternating with rows of lozenge-shaped red and green elements.

For an average subject in bright sunshine the Dioptichrome plate required an exposure of one second at f/11. The screen transmitted 21% of the light falling on it – a great improvement over the $7\frac{1}{2}\%$ of the Autochrome plate. H. Essenhigh Corke, a leading colour worker, said, 'on the score of brilliance and transparency the Dioptichrome is a very great advance upon the Autochrome'. While the quality and saturation of colour were good, the Dioptichrome plates were often defective, with pinholes which produced green stains around each spot. They were on the market until the First World War, after which they were replaced by the Dufay Versicolor screen plate, first described in 1917 and using an alternative method of production by which the screen was formed by a technique involving grooving a celluloid sheet by embossed rollers.

Many ideas for screen-plate processes were patented and published in the years before the First World War. Two which in 1909 reached the stage of public demonstrations, although they achieved no great commercial use, were the Aurora and Veracolor processes. E. Fenske's Aurora plates were made by grinding up dyed material and sifting the mixed powders on to tacky plates. The angular particles, of markedly different sizes, made an irregular screen. The unusual feature of this process was that this screen was used with a

separate negative plate – the only irregular screen-plate process where this was done. The problem of registering the positive plate with the original taking screen was considerable. The Szczepanik-Hollborn Veracolor screen was made by first dyeing solutions of gelatin or gum in each of the three primary colours. The gums were dried out and powdered very finely, and were then mixed to give a powder of neutral shade. The mixed powder was pressed on to a dampened collodion-coated plate, and the dyes migrated from the particles into the collodion film to form an irregular screen. The now colourless gum powder was washed away, and the screen was coated with emulsion which was exposed and reversal-processed in the usual way.

Geoffrey S. Whitfield of London devised and published in 1912 a regular screen process in which the screen was produced on a collodion-coated plate first dyed red. The surface was partly covered by a pattern of lines printed in a water-resistant material, and the plate was bleached. The clear spaces so produced were dyed green, and a second pattern of resist lines was printed, followed by a

second bleach. The clear squares remaining were dyed blue, giving a pattern of two blue squares to each red and green square. The elements were about 1/300 inch in size (0.08 mm). Both separate and combined versions were produced and sold under the name Paget Colour Plates. They were shown at the Photographic Arts and Crafts Exhibition in London in May 1912, and were placed on the market in April 1913. The Paget Colour Plates were sensitive enough to allow exposures of around 1/25 second at f/4.5. The *British Journal of Photography* said of them, 'The colours of the Paget plates never came up to the rich warm colours of the Autochrome plates', but they were capable of a delicate rendering of subtle colours. They were discontinued in the early 1920s, as the price of the screens had risen to an almost prohibitive figure after the First World War.

For a short time the Paget process was also available for paper prints. In this form it was shown at the Royal Photographic Society Exhibition in 1912. A less saturated form of the viewing screen was combined in register with a

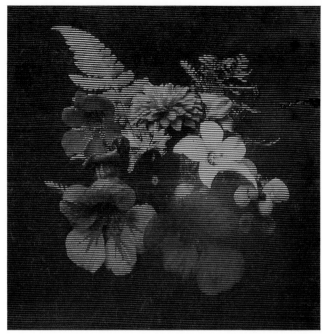

Far left *King's College Chapel, Cambridge c. 1912. A remarkable study on an Autochrome plate, which must have required an exposure of many minutes (110 × 155 mm)*

Above left *French soldiers relaxing at cards, 1916. From a stereoscopic Autochrome plate (60 × 60 mm)*

Above right *Flower study photographed on a Krayn combined line screen plate; on September 19, 1909. The process is described on page 56 (60 × 62 mm)*

Left *Boy with parasol, 1908. Despite the obvious reluctance of the sitter, the unknown photographer has made an attractive photograph on his Autochrome plate (73 × 98 mm)*

Whitfield's Paget Colour process used taking screens combined with Paget Panchromatic Plates to make the negatives. These were printed on Paget Transparency Plates, and these positives were bound up in register with Paget Viewing Screens.

transparency on glass, and silver paper was squeegeed on to the back; the combined picture, screen and silver paper could be then stripped from the glass for viewing. An improved version was shown in 1914, in which the negative plate was printed on a silver paper coated with emulsion, and a special viewing screen was registered with the still wet print and squeegeed down. When dry, the support of the screen could be stripped from the print. A reviewer said it 'compared with a Daguerreotype *plus* the charm of colour'.

The process had little success, since the prints had to sacrifice colour saturation for brightness. In addition, as the *British Journal of Photography* pointed out, the basic dyes used for the screen 'cannot be regarded as of a high degree of permanence'. They were satisfactory when lit only intermittently in a lantern slide, but would fade after months of exposure in room light, as might well happen to a displayed print. However, the Paget Printing Process was one of the very few *additive* colour printing processes to see any kind of use.

The last screen-plate process to appear before the First World War was the Leto colour plate, devised and patented by O. S. and H. E. Dawson, and shown by the Leto Photo Materials Company at the Photographic Arts and Crafts Exhibition in London in April 1913. It was a separate screen process, the screen consisting of green lines with a row of red circles between them. The spaces between the circles were coloured blue. No significant commercial application followed.

During the war, an important new screen plate appeared, based on patents taken out by J. H. Christensen in 1908. He proposed to make a concentrated solution of gum in alcohol. Divided into three parts, the gum solutions were dyed red, green and blue, and emulsified in turpentine. The three emulsions were mixed and flowed on to a tacky varnished plate, where the gum droplets stuck to form an irregular mosaic. They were then rolled down so that each particle came into complete contact with its neighbours, removing the need to fill remaining spaces with opaque material, as the Autochrome plate had required. Christensen's patents were acquired by Agfa AG in Germany, and experimental results were shown in 1912 in Berlin by Dr A. Miethe. The Agfa Colour process was introduced commercially in Germany in 1916, but for obvious reasons did not reach the English market until 1923. The coated Agfa Colour plate had a similar speed to Autochrome, and was developed by a similar reversal process.

Leto Colour Photography outfits were on the market for a short time in 1913. Like the Paget process, they used separate taking and viewing screens and plates

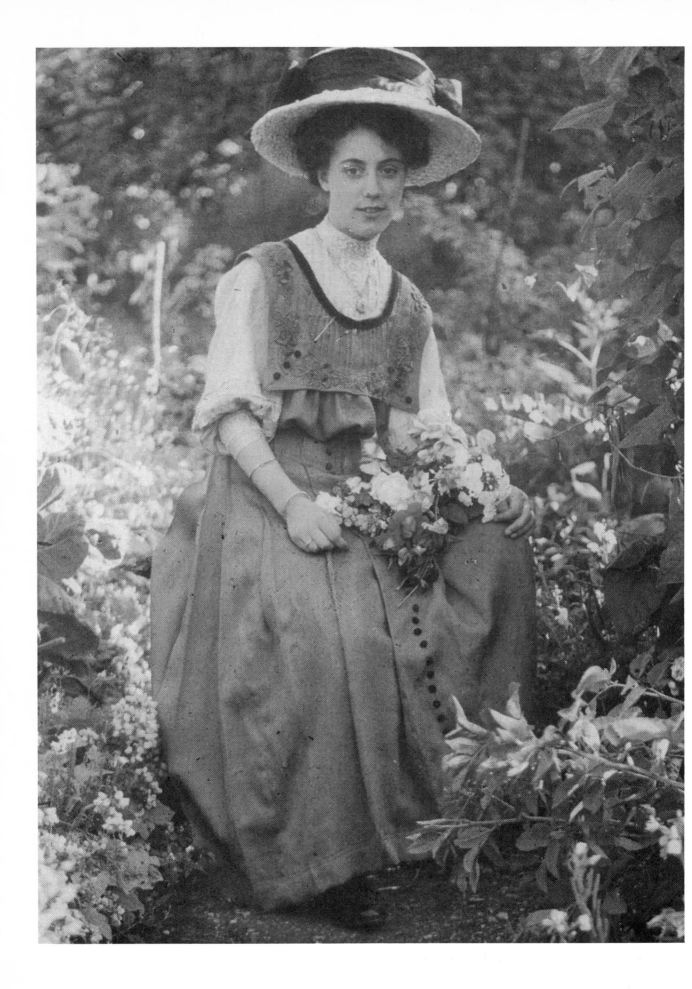

Far left *Edwardian lady, photographed on August 21, 1909, on a separate screen Thames colour plate (see page 57). This process, devised by Clare L. Finlay, was on the market for about two years only (75 × 102 mm)*

Above left *Nude, photographed on an improved Dufay Dioptichrome combined screen plate, 1912 (110 × 160 mm) – see page 60*

Above right *Grecian study – an improved Dufay Dioptichrome combined screen plate, c. 1913 (75 × 104 mm)*

Left *Reputed to be a portrait of the inventor, Louis Dufay, taken on his improved Dioptichrome combined screen plate, 1912 (120 × 170 mm)*

Above *Part of an advertising leaflet for the Lignose Natural Colour Film, 1926*

Right *An advertisement for the Finlay Colour Process, a revival of the earlier Paget process*

The *British Journal of Photography* reported, 'The colour elements are particularly fine in grain and so transparent that . . . positives in rich but pleasant soft colouring are obtained'. The Agfa Colour plate was a potent rival to the Autochrome process, although it suffered from the same problem of clumping of the colour particles. A box of four Agfa Colour plates cost 4s in 1923, in quarter-plate size, compared with about 2s 9d for a dozen black and white plates of the same size.

The defunct Paget process was revived in 1926 in the form of Charles Baker's Duplex process. Improved separate screens, of the same arrangement as the Paget plates, and new negative plates, made by Wellington and Ward, made possible exposures of 1/30 second at f/4.5 in open landscapes. The new plates were made in two sizes

only, $2\frac{1}{2} \times 3\frac{1}{2}$ inches (6 × 9 cm) and $3\frac{1}{4} \times 4\frac{1}{4}$ inches (8.25 × 10.8 cm). Also in 1926 a colour screen process on film instead of glass appeared. It was not the first colour screen film process; in 1910 the German Neue Photographische Gesellschaft sold a rollfilm bearing a screen of red lines between rows of diamond-shaped green and blue-violet elements, based on an invention by Robert Krayn, but it had only modest commercial success. It was unusual in that the exposed film was developed to a colour negative, which was then printed on to a similar screen film to make positive transparencies.

The new process, Lignose Natural Colour Film, used an irregular mosaic of elements, of average size 1/2822 inch (0.009 mm), of very similar appearance to the Agfacolor screen. The exposure, which was still a lengthy one, requiring about sixty times longer than a black and white film would have needed, was followed by reversal processing. On the whole the results were good, and the *New Photographer* reported, 'The films are remarkably free from manufacturing blemishes, so hard to avoid in this type of material.' The Lignose process was available as sheet film (in nine sizes), film packs (in five sizes) and rollfilms (in five sizes). A three-exposure rollfilm, of 120 size, cost 2s 9d compared with 1s 2d for a six-exposure black and white film. A developing service was available, at a cost of 2s 9d for the 120 size film.

One of the last colour screen processes on glass plates appeared in the summer of 1929. The Finlay Colour Process used a screen of red, green and blue squares, of virtually identical arrangement to the earlier Baker Duplex and Paget plates, and made use of new high-speed negative plates such as Ilford Hypersensitive or Barnet Ultrasensitive Panchromatic plates, which gave shorter exposure times and greater exposure latitude. A combined version, with the screen plate coated with reversal emulsion, was sold under the name Finlaychrome from 1931. The Finlay Colour Process saw a very brief revival in 1953 when it appeared under the name of Johnson's Colour Screen process.

In 1931 Franz Piller introduced a process for the production of colour prints on paper. In principle, it was like the earlier Paget Printing Process, except that the taking screen had ruled red, green and blue lines at 300 to the inch (12 to the mm). The negative exposed through the line screen was printed on to aluminium-surfaced paper on which had been printed a series of coloured lines, exactly corresponding to those on the taking screen, on the top of which an ordinary emulsion was coated. A special micrometer-adjusted printing frame

The Finlay Colour Process

The newest and best method of taking photographs in natural colours.

For the Amateur—

1. The *only* Process which can provide indefinite copies of duplications in colour from ONE negative.
2. Cheaper than any other colour process because you can use the Finlay colour screen over and over again.
3. Can be used with *any make and any size plate camera.*

For the Professional—

1. A License to use the process for professional purposes may be had on attractive terms.
2. Invaluable for portraiture, commercial catalogues, studio sets for advertisers and any photographic work involving high speed. Can be used in daylight, artificial light and flashlight.
3. Adopted by the National Geographic Magazine of America for colour work involving movement.
4. Examples of Finlay Colour work can be seen in the Illustrated London News, Sketch, Sphere, Tatler, Bystander and Punch and in the Ladies' Home Journal of New York.
5. The new *Colour Positive Screen* opens up a wide field for the use of the Process for colour advertising in Theatres, Cinemas, Stores and Transport Companies.

DEMONSTRATIONS CAN BE GIVEN AND LICENSEES TAUGHT HOW TO USE THE PROCESS IN LONDON OR NEW YORK.

Head Office for Europe : Byron House, St. James's St., London, S.W.1.
Head Office for America : 305, East Forty-Fifth Street, New York City.
Factory : Slough Trading Estate, Bucks, England.
Research Laboratories : Watford (England) and Paris.

Finlay Photographic Processes, Limited
Byron House, St. James's Street,
London, England

Telephone : Regent 1083. Cables : Fintocess, London

Above *Fun with the cart, c. 1914. A combined screen Paget plate, by the process devised by Geoffrey Whitfield, described on page 61 (97 × 72 mm)*

Right *The rose arbour, c. 1914. An informal portrait on a combined screen Paget plate, by a particularly colour-conscious photographer (72 × 97 mm)*

Above The Finlay process used separate taking and viewing screens, combined with negative and positive plates

Right A display poster for the Dufaycolor film process, advertising the wide variety of film types and sizes available in this process

allowed the negative plate and the paper to be precisely aligned for printing, and registration marks were provided to facilitate this. The colour of the prints was rather unsaturated, but was 'pleasing and satisfactory', said the *British Journal of Photography*. The Piller process did not have great commercial success.

The increasing trend in general photography away from glass plates towards films in the 1920s and 1930s influenced the development of several of the longstanding colour screen processes. In 1931, the Lumière company placed on the French market a sheet film version, in nineteen sizes, of the Autochrome plate, under the name Filmcolor. The new films were somewhat faster than the plates, and more convenient to use. Film packs and rollfilms soon followed, and by the mid-1930s

Filmcolor had virtually replaced the Autochrome plates. A four-exposure rollfilm of 120 size cost 5s 6d in 1935, compared with 1s for an eight-exposure black and white film. Agfa AG, who had acquired the rights to the Lignose film process, followed in 1932 with Agfacolor films, in rollfilm and film pack forms, as well as sheet films. In 1934 Ultra Agfacolor rollfilms and film packs appeared, six to eight times faster than the Agfa Colour plates, allowing exposures of 1/30 second at f/4.5 in well lit scenes. No correction filter was needed for daylight use – the first time this had been so for a screen-plate process – and the colour was generally regarded as excellent.

The last additive screen-film process to appear was derived from the earlier Dufay Dioptichrome plate. The new Dufaycolor film had a very fine, regular screen printed on a non-inflammable film base coated with collodion. After this layer was dyed blue, a set of resistant greasy ink lines was printed on it, at 500 to the inch (20 to the mm), with spaces equal to the line thickness. The dye between the greasy lines was bleached, and the film re-dyed green, giving alternate green and blue lines. After washing off the first set of greasy lines, a second set was printed at right angles, but this time the lines were thicker than the spaces between them. The film was bleached again, leaving clear spaces between the lines, and these were dyed red; finally, the ink lines were removed, leaving a screen of red lines alternating with rows of green and blue rectangles, the three colours having approximately the same area. The screen was then varnished and coated with panchromatic emulsion.

The Dufaycolor process was introduced as a ciné-film by the Spicer-Dufay company in England in 1932, but it was not sold in a form for still photography until 1935. Ilford Ltd marketed it in that year in rollfilm, sheet film and film pack forms, and offered a processing service for the rollfilms. A 120 size rollfilm, for six exposures, cost 3s 4d, over three times the cost of an eight-exposure black and white film in 1935, and processing cost a further 1s 6d. The Dufaycolor film was processed by reversal development, and was about one third of the speed of a conventional black and white film of the day, equivalent to about ASA 10. This was fast enough to permit exposures of 1/50 second at f/8 with sunlit subjects. The very fine screen structure, increased sensitivity and relatively simple processing cycle made Dufaycolor film popular with both amateur and professional photographers, and it survived into the 1950s. The screen process could not survive the competition of

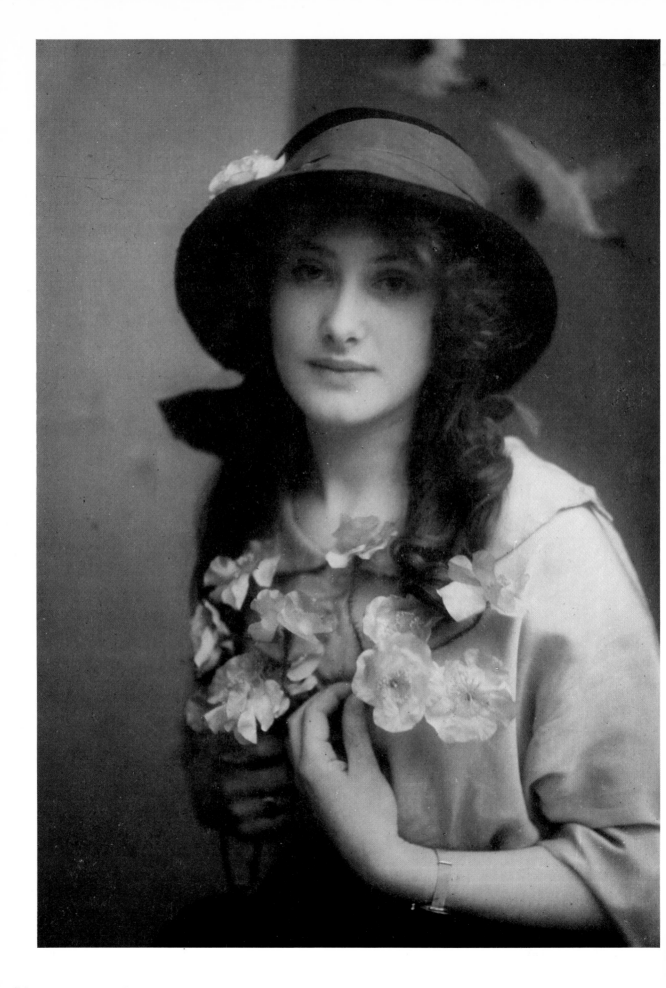

Far left *Girl with flowers, c. 1913. A separate screen Paget plate, photographed by A. C. Banfield, FRPS (110 × 154 mm)*

Left *The garden path, c. 1928 – an Agfa Colour screen plate, by the process described on page 64 (80 × 102 mm)*

Below *Bavarian landscape, c. 1928, on an Agfa Colour screen plate (117 × 167 mm)*

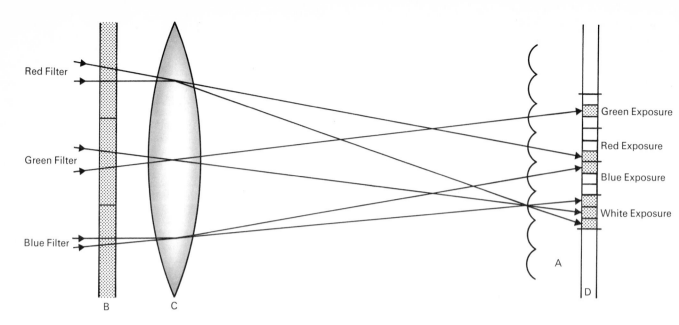

Red Filter

Green Filter

Blue Filter

B C

Green Exposure

Red Exposure

Blue Exposure

White Exposure

A

D

Above *Keller-Dorian, Berthon film. Each of the lenticles on the film A produces an image of the three band colour filter B, placed in front of the lens C, on the emulsion layer D. Light passing through the red, green and blue sections of the filter exposed the emulsion in narrow strips behind each lenticle, the position of the exposed strip being determined by the colour of the object at that point. The film was processed to a positive, and the projection arrangement was identical to the taking system, but in reverse. Each lenticle directed rays of light passing through the image out through the section of the filter appropriate to each colour*

Right *A Keller-Dorian, Berthon 35 mm film exposed in a Leica camera in 1927. The lenticular structure produces a line image which can be seen clearly in the magnified section below*

Below *The edge of the lenticular colour film, magnified 180 times in a scanning electron microscope. The lenticles on the surface 1 can be seen in section on the edge 2. The sensitive emulsion 3 is a thin layer on the underside of the film*

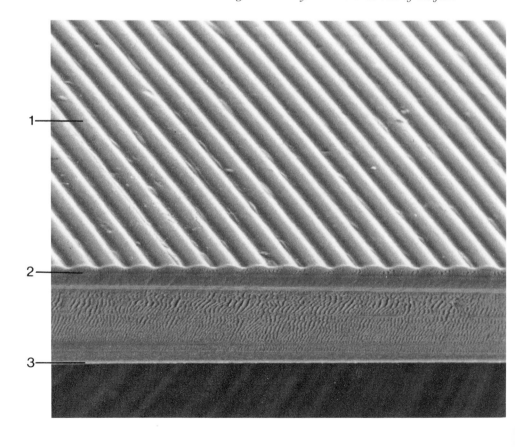

1

2

3

Above left *The two friends – photographed on Lignose Natural Colour film, c. 1927. Lignose (see page 68) was the first colour rollfilm process to have any commercial success (106 × 78 mm)*

Above *Flatford Bridge, Suffolk, 1931. A combined screen Finlay Colour plate, a revival of the earlier Paget process, using improved negative plates (see page 68) (210 × 157 mm)*

Far left *Krayn screen film positive of a flower study, printed from a Krayn screen film negative, made by the process introduced in 1910, and described on page 68. The greenish vertical lines are moiré pattern effects, the result of printing one screen film on another (72 × 105 mm)*

Centre left *Piller Colour print, 1931. One of the very few additive colour print processes, Piller's method used aluminium coated paper ruled with fine red, green and blue lines. The process is described on page 68 (75 × 55 mm)*

Left *Lumière Filmcolor transparency, from a stereoscopic pair exposed in 1935. Filmcolor had the same structure as the Autochrome plate, but was coated on film instead of glass (54 × 60 mm)*

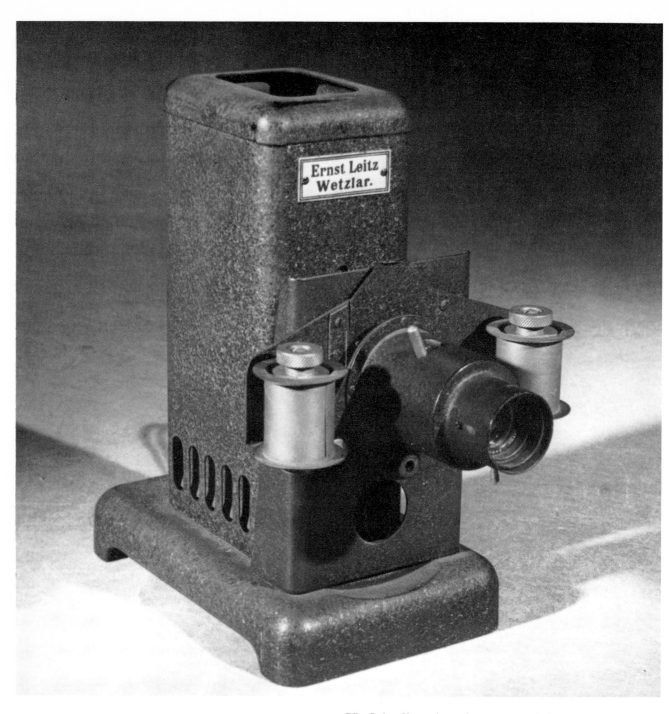

The Leitz film strip projector, 1927, designed to project lenticular film transparencies made on Keller-Dorian, Berthon film

the modern screen-less colour processes, and by the later 1950s all had disappeared. The principle has, however, been revived for colour television, where the picture is produced in the form of minute red, green and blue dots 'lit' by signals derived from electronic colour cameras which analyse the scene in terms of those three primary colours.

An elegant method of colour photography which used films embossed with tiny lenses was first proposed by the Frenchman R. Berthon in 1909, when it was patented. Immediately in front of the camera lens he placed a filter of three bands of colour, red, green and blue, completely covering the lens. The base of the film was embossed on the back with rows of minute lenses or 'lenticles' which produced an image of the banded filter on the emulsion, which was placed away from the lens. This produced an optical equivalent to the colour screens we have already considered. Light from the subject reaching the banded filter would be absorbed or transmitted as appropriate, so that, for example, red parts of the scene would be recorded on the film only at the points where the red filter was imaged by the lenticles. After reversal processing, the film was projected by a similar optical system, with a banded filter over the projection lens. The lenticles directed each point of light passing through the image out through the filter band appropriate to it, so that a full colour image appeared on the screen, made of many rows of minute red, green and blue lines of varying density. Berthon's idea was developed by another Frenchman, A. Keller-Dorian, who devised various ways of embossing film with lenses of different forms. Demonstrations of the KDB process (Keller-Dorian, Berthon) in motion picture form were given in 1923 and later, but the considerable difficulty in making copies from the original lenticular film severely limited its use in the cinema. The Eastman Kodak Company produced a 16 mm film version for home movies, using 550 cylindrical lenses to the inch (22 to the mm) embossed on the film, under the name Kodacolor film in 1928; it remained on the market until 1937. The KDB film could be used in 35 mm still cameras such as the Leica, if fitted with a three band filter on the lens, and in 1928 Leitz produced a strip projector with a filter incorporated in the lens for the projection of lenticular films exposed in this way. In 1933 Leitz sold an attachment for the Leica camera used with a lenticular film manufactured by Agfa. The process saw little commercial use in still photography, however.

The Leitz projector fitted with a three band colour filter

Above left *Paris Exposition, 1937; a Dufaycolor rollfilm transparency (52 × 81 mm)*

Far left *'4711', photographed on Dufaycolor cut film by Dr D. A. Spencer in 1938 (190 × 235 mm)*

Centre left *The lake – a photograph on Agfa Colour screen film, c. 1932 (83 × 115 mm)*

Above *St Paul's, London, in wartime, c. 1943. A Dufaycolor rollfilm transparency (110 × 83 mm)*

Left *After the air raid, London, photographed on Dufaycolor rollfilm, c. 1943 (110 × 83 mm)*

4 Colour by subtraction

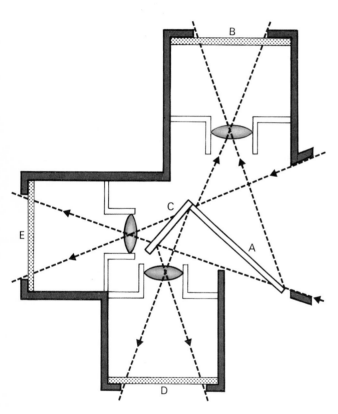

Above *In the camera proposed by Ducos du Hauron, light from the subject was reflected from the transparent reflector A to a camera with a violet filter B and a blue sensitive plate. Light passing through reflector A was partly reflected by reflector C into a second camera with a green filter D and a green sensitive plate. Finally, the light passing through both reflectors entered a third camera with an orange filter E and appropriately sensitised plate*
Right *Sanger-Shepherd's camera of 1902 (below) had two reflectors behind the lens which directed light to plates on either side of the camera; light passing through them reached a third plate at the back. The filters were placed immediately in front of the plates. The Sanger-Shepherd one-exposure camera of 1907 used prisms behind the lens to split the light beam into three to make three negatives on one plate*

So far, the processes we have considered have built up a colour reproduction by adding together three light impressions coloured red, green and blue, either by projection or other forms of optical combination, or by the use of colour screens, the minute elements of which combine in the eye when seen from a distance. Dr D. A. Spencer has compared this additive principle with the techniques of the modeller, who starts with an empty stand and adds clay to it until his whole creation is complete. However, there is another way of creating a similar object. The sculptor takes a block of wood or stone, and carves away the material which is not needed. In photography, we might begin with white light, in which all colours are present, and remove those colours we do not want so as to reproduce the original scene. We have already referred to the paper by Ducos du Hauron written in 1862; in it he outlined a method of producing colour prints on paper; he gave practical details in his French patent of 1868, and in his book *Les Couleurs en Photographie* the following year.

He proposed that three negatives be made of the same subject, by orange light, green light and violet light. Three positives could then be made from them, printed on semi-transparent paper 'prepared with the complementary colours'. The orange record was printed in cyan (blue-green), the green record in magenta (blue-red) and the violet exposure in yellow (a red-green mixture). When the three positives were carefully superimposed, a full colour reproduction would result. Each of the three complementary colours absorbs or subtracts one of the primary colours. Thus, a cyan image, depending on its density, will vary the amount of red light passing through it, performing

SANGER-SHEPHERD ONE-EXPOSURE CAMERA.

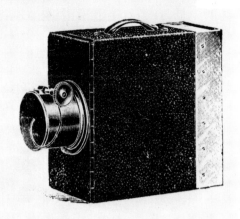

QUITE THE SIMPLEST WAY FOR AMATEURS TO PHOTOGRAPH IN NATURAL COLOURS WHICH FOR PURITY ARE ONLY EQUALLED BY THOSE UPON THE FOCUSSING-GLASS.

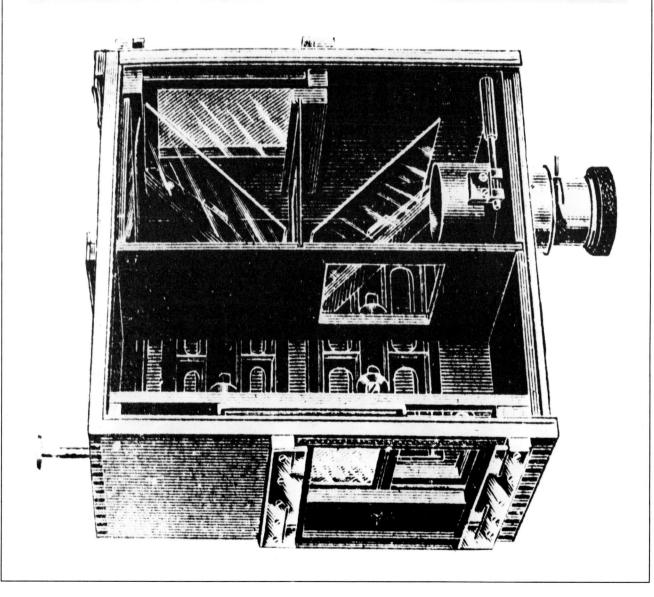

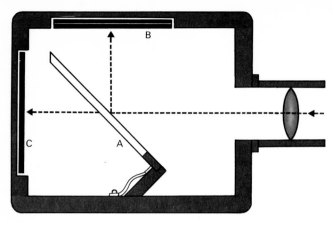

Bennetto's camera, patented in 1897, used a single red glass reflector A, set at a 45° angle inside the camera. Light reflected from it reached a bipack of two plates B on the top of the camera. The lower plate was blue sensitive, and the upper was additionally sensitive to green. A yellow filter was set between them to absorb unwanted blue light. The red reflector transmitted some light to expose a red sensitive plate C at the back of the camera

the same function as the black and white image and red filter of the additive process. Similarly, the magenta filter controls the green light passing through it, and the yellow image the blue. By superimposing them, the three colours will produce all the others. Red is produced by superimposing magenta and yellow, green by superimposing cyan and yellow, and blue by superimposing cyan and magenta. This form of colour mixing is the same as that of the artist, whose 'red' and 'blue' are in reality magenta and cyan.

The subtractive process has a number of advantages. The additive processes involved using filters which by their very nature absorbed more than two-thirds of the light passing through them, so that even the brightest part of the scene was represented by as little as 10% of the light falling on the photograph. A subtractive process on the other hand would represent white by clear glass or white paper, sending most of the available light to the eye. Among other advantages, this makes colour prints on paper perfectly practical. Since the final image in a subtractive process would consist of dyes or very finely divided pigments, there would be no obtrusive screen structure, or need for cumbersome viewing devices.

In 1869 Ducos du Hauron showed examples of colour prints of landscapes which he had made by this method, and his English patent of 1876 gave a clear description of the basic form of the subtractive process. He pointed out that a triple camera was desirable to enable all three colour records to be made at the same time, and suggested a design using triple lenses and mirrors. The search for suitable designs of such cameras occupied the fertile imaginations of countless inventors in the years to come. Ducos du Hauron also pointed out the need to sensitise plates to respond to colours other than blue, suggesting that aurine or eosine would sensitise for green, and chlorophyll for orange light. As we have seen, Dr Vogel's work three years before had pointed the way for the use of sensitising dyes.

The development of practical methods of colour photography on the principles laid down by Ducos du Hauron followed two lines. One was the design of apparatus for producing the three sets of separation negatives required to analyse the subject in terms of red, green and blue content. The other was the development of methods for the production and superimposition of the three complementary positives. These two aspects can be considered separately, since the methods by which

the negatives were made did not influence the printing methods, and vice versa.

Ducos du Hauron's French patent of 1874 and English patent of 1876 describe the archetypal colour camera, establishing the principles followed by many designs that came after.

> 'The rays coming from the subject to be reproduced are received upon a glass unsilvered with parallel faces, inclined 45°, or thereabouts, in respect to the model and . . . to a first lens, towards which it reflects a part of the above-mentioned rays. The greater part of these rays traverse this first glass, and they are received by a second glass . . . also inclined 45° . . . in relation to a second lens towards which it partially reflects the rays it receives. Lastly, the rays that this second glass allows to pass are received by a third lens . . . In virtue of this arrangement the three images received by the three lenses are geometrically the same.'

Of the very many patterns of three-colour cameras designed and patented in later years, many were wildly impractical. This is especially true of those with three separate lenses or external mirrors or prisms to split the light beam. Such systems produce images from slightly different viewpoints, making it impossible accurately to register the results. Only a few of the more important, commercially successful designs can be discussed here.

J. W. Bennetto's English patent of 1897 describes a camera with a single reflector made of red glass. Light from the surface of this reflector, which lay at an angle of 45° across the inside of the camera, was reflected up on to a bipack (two plates placed emulsion to emulsion) lying at the top of the camera. The plate nearest the reflector was blue-sensitive only, while the upper plate was in addition sensitive to green light. A yellow filter placed between them cut out the unwanted blue rays. Some of the light passing through the red reflector reached a red-sensitive plate at the back of the camera. A variation of Bennetto's design, with the reflector set at an oblique angle to the rear plate to compensate for distortion of the image as it passed through the reflector, was patented by O. Pfenniger in 1910, and was used at the Dover Street Studios in London, who were operating the Polychromide process from 1911 to 1913.

E. T. Butler's camera, patented in 1897, used two transparent reflectors one behind the other, in an arrangement rather like that of Ives' Kromskop which we considered in Chapter Two. The first reflected light up through a red filter to a suitable

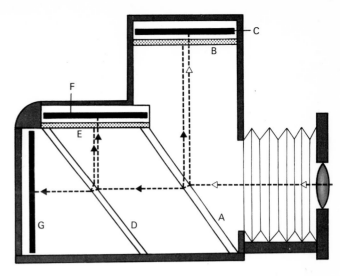

Above *In Butler's colour camera, 1905, a transparent cyan glass reflector A reflected white light from its surface through a red filter B to a red sensitive plate C. Cyan light reflected from the rear surface of the reflector was prevented from reaching the plate by the red filter, avoiding a double image. Light passing through the reflector reached a yellow glass D, from the surface of which some light was reflected through a blue filter E to a plate F. As before, the reflection from the rear surface of the yellow filter was absorbed by the blue filter. A green sensitive plate G at the rear was exposed by light passing through both cyan and yellow reflectors*

Below *The camera designed and patented by A. E. Conrady and Aaron Hamburger in 1912 had a single transparent reflector, reflection from which exposed a single plate in a holder on the side, and transmission through which exposed a bipack of two plates at the back. A linkage between the lens panel and the rear plateholder caused the angle of the latter to be altered automatically as the camera was focused, to compensate for optical distortions that would otherwise occur.*

A complex system of screws and springs allowed the reflector to be slightly distorted to ensure exact registration of the reflected and transmitted images. The camera, which was constructed by W. Watson and Sons, was used at the Dover Street Studios in London

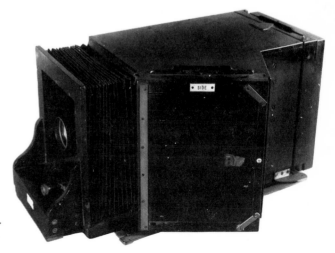

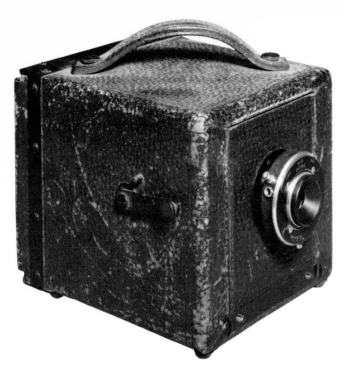

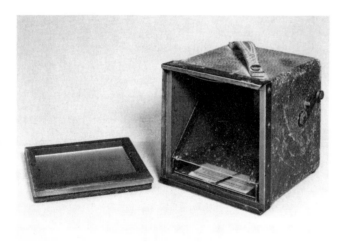

The Hicro Universal camera, 1914, used a bipack and a single plate loaded as one unit. When the reflector was raised by the lever on the side, the single plate would fall forward to the bottom of the camera, where it could be exposed by reflection from the surface of the lowered reflector. The bipack at the back was exposed by light passing through the reflector. Ives' Hicro process is described on page 101. An example appears on page 95

plate at the top of the camera, while light passing through the reflector met the second, from which a proportion was reflected up through a blue filter to a second plate above. Finally light which had passed through both reflectors passed through a green filter to a third plate at the back. Butler patented an improved model with cyan and yellow glass reflectors in 1905. Cameras based on the Butler pattern were sold and used over many years.

The Sanger-Shepherd camera of 1902 also had two reflectors, but arranged them differently. Light from the lens met first a transparent reflector at 45°, which sent some light off to a red filter and sensitive plate at the side of the camera. Light passing through this reflector met another at right angles, which directed a further proportion through to a blue-sensitive plate and blue filter on the other side of the camera. Finally, light passing through both reflectors reached a red filter and plate at the back of the camera. (This pattern was used in a number of later cameras, notably the Bermpohl and Devin cameras, popular in the 1930s.) Later, in 1907, Sanger-Shepherd sold a very compact three-colour camera in which prisms behind the lens split the light into three beams, which exposed the three separation negatives side by side on a single plate, the appropriate filters being placed just in front of the plate.

F. E. Ives' Tripak camera of 1910 used a Bennetto-type single reflector arrangement. The three plates were held in a single, special plateholder. Red- and green-sensitive plates were held face to face, and a blue-sensitive plate was hinged at the bottom to the bipack and to a backing card. The camera was of box form, and the plateholder was inserted with the reflector turned to the top of the camera by a handle. When the darkslide was withdrawn, the blue-sensitive plate was allowed to fall to lie horizontally at the bottom of the camera. The reflector was then dropped to a 45° angle, so that light reflected from it would reach the plate at the bottom. Light passing through the reflector exposed the bipack at the back. To remove the plates, the mirror was raised, the camera up-ended to restore the blue plate to the holder, and the darkslide returned. The camera was introduced commercially by the Hess-Ives Corporation of Philadelphia, as the Hicro-Universal camera in 1914. It was made, under contract, by the Eastman Kodak Company's Hawk-Eye works, in two sizes, for $3\frac{1}{4} \times 4\frac{1}{4}$ inch (8.25×10.8 cm) and $3\frac{1}{4} \times 5\frac{1}{2}$ inch (8.25×14 cm) plates.

H. Workman's design, patented in England in

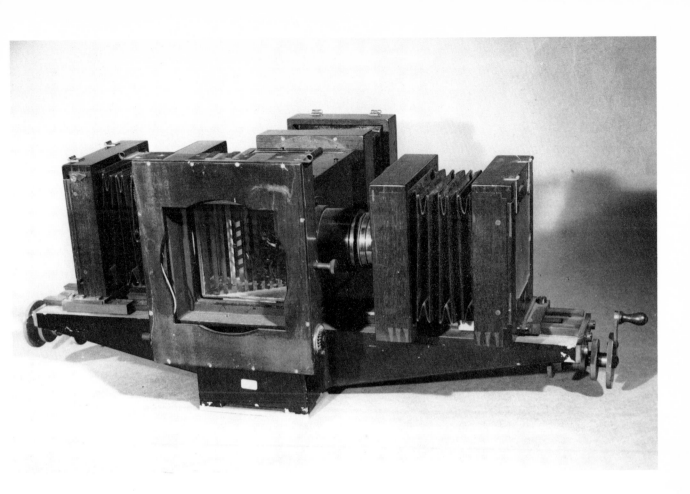

1915, used a group of prisms assembled as a cube, with two of the internal surfaces bearing parallel lines of silvering, one set running vertically, the other horizontally. Three small cameras with Cooke lenses were set up looking into three of the four sides of the block. Light reflected from the vertical silvered lines was sent to the camera on the right, and that from the horizontal lines to the left. Light passing through the spaces between both sets of lines reached the camera at the back. The colour filters were placed in recesses just in front of the plateholders, and the camera backs were moved in and out for focusing by operating a single handle connected to all three. A large roller-blind shutter set in front of the prism block made the exposure.

The Jos-Pe camera, patented in 1924, was manufactured from 1925. It was awarded a medal at the Frankfurt Exhibition in 1926. Named after the designer, Jos. P. Welker, it was made in two models – the Uka was a professional version for 9 × 12 cm plates; the Liliput amateur version took 4.5 × 6 cm plates. Two small mirrors were fitted close to the back of the lens, reflecting light to plates in holders on either side of the camera. Light passing between the mirrors reached a third plate at the back. A single focusing control moved all three backs simultaneously. The makers claimed that

Workman's triple colour camera of 1915 used three small cameras, whose backs were moved simultaneously for focusing by turning the handle on the right. A prism block, with horizontal and vertical silvered lines on its internal surfaces, directed light into three cameras, which were fitted with Cooke lenses. A large roller blind shutter on the front controlled the exposure

Left '*Miss Lena Ashwell*', a three-colour carbon print, from separation negatives, by A. C. Banfield, FRPS, 1907. The edges of the three superimposed coloured tissues can be seen clearly in this unmasked print. The process is described on page 97 (178 × 230 mm)

Above *King George V and President Truman on board HMS Renown*, 1945. A three-colour carbon print from a Dufaycolor transparency (110 × 150 mm)

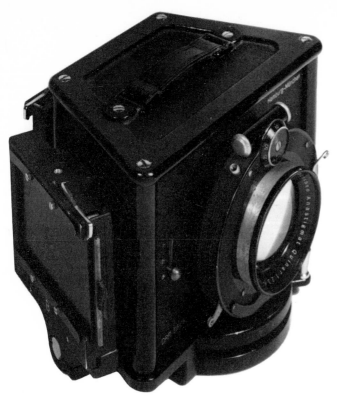

The Jos-Pe camera, 1925, had two small reflectors immediately behind the lens to direct light on to plates on either side of the camera, while the third plate at the back was exposed by light passing between them. A focusing control moved all three backs at once. This example is of the small amateur version, Liliput, which took 4.5 × 6 cm plates

exposures as short as 1/50 second in sunshine were possible.

Albert George Hillman's colour camera, patented in 1930, used an unusual mirror system behind the lens. A circular mirror was suspended in the centre, reflecting light to a plateholder on the right side. Surrounding the circular mirror was another, ring-shaped mirror, reflecting light to a second plateholder on the left. Light passing through the gap between them reached a plate held at the back. It was claimed that the camera, which was manufactured by Adam Hilger Ltd, could be used for exposures as short as 1/100 second at f/3.5.

The Mikut One-shot colour camera, introduced in 1936, used a prism system behind the lens to split the beam into three paths, exposing the three negatives side by side on one plate, through a set of filters placed just in front of the plate. The camera had several advanced features, notably a coupled rangefinder system.

The Czech Coloretta camera (later the Spektaretta) was patented in 1937, and was unusual in employing 35 mm film. The film was carried around the stepped back of a prism block fitted behind the lens, and by multiple reflections from the internal surfaces of the prism block the beam was split into three, exposing three adjacent frames on the film at once.

The 'one-shot' cameras we have considered so far were necessary when photographing subjects where movement or change could occur. Where this was not the case, for example with still-life subjects, the three separation negatives could be taken in succession. Of course, this could be done in a conventional camera, changing colour filters on the lens after each exposure, but this could be rather tedious if much colour work was to be done. Various repeating back devices were developed to facilitate the exposure of the three plates through the three filters.

An early example of such a colour repeating back was patented by G. Selle in Germany in 1896. A long plateholder, fitted with the three filters, could be slid past an aperture in the camera back in three steps. We have already considered F. E. Ives' version of this idea in Chapter Two, and a similar model was introduced by Sanger-Shepherd around 1900. In this model the three filters were fitted in a frame placed just in front of the long plateholder, and slid along with it. Springs, at first of brass, but after 1902 of German silver, held the plateholder and filter frame in position, and a catch located them for each exposure. This repeating back was available from Sanger-

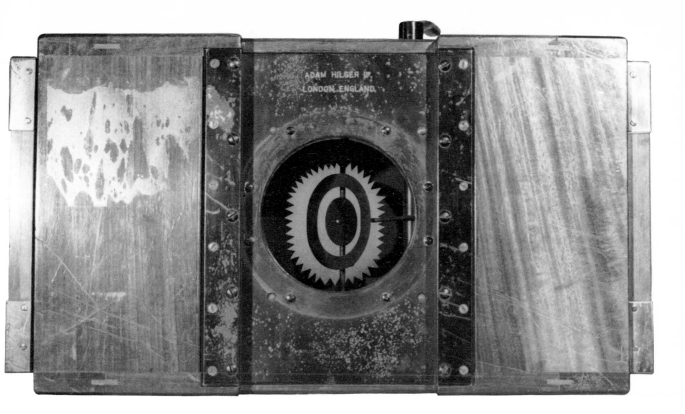

Shepherd in a variety of plate sizes, and could be fitted to most plate cameras. An improved quick-change model was issued in 1907, in which the plateholder and filter frame in position, and a catch located them for each exposure. This mechanism. The total time for the three exposures 'rarely need exceed 3 seconds for landscapes', said the advertisements. Also in 1907, Sanger-Shepherd sold a Stereoscopic Set – a box form stereoscopic camera with a vertically placed repeating back, which took three stereoscopic pairs of separation negatives.

R. Lechner's colour camera of 1911 consisted of an ordinary folding plate camera with a plate box on the back. Three plates were carried, on the faces of a triangular block which was rotated by clockwork. A double cable release allowed the shutter to be worked and the plate block to be rotated in quick succession. A similar idea had been patented as long ago as 1898 by A. Hofman in

Above Hillman's one-shot camera, made in 1930 by Adam Hilger, used circular and annular reflectors behind the lens to direct some light left and right to plates held on the sides of the camera. A third plate at the back was exposed by light passing between them (the lens has been removed to show the reflectors)

Below The Mikut colour camera of 1936 had a prism system behind the lens which divided the beam into three approxi-mately equal parts, as can be seen clearly from the back of the camera (left). The Mikut was fitted with a coupled rangefinder to facilitate focusing. The colour filters were placed immediately in front of the plate on which the three exposures were made, side by side

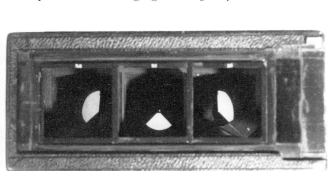

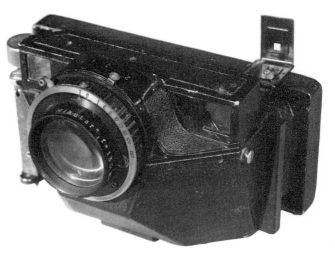

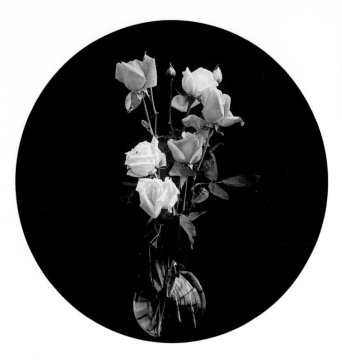

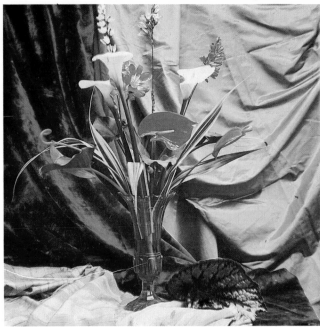

Above *Roses – a Pinatype transparency by Dr E. König, 1905 (70 × 70 mm)*

Above right *Arum lilies – from a Lumière 'bichromated glue' stereoscopic transparency, c. 1900. The Lumière process is outlined on page 100 (68 × 68 mm)*

Right *Riverside buildings – a Pinatype print, c. 1907. Pinatype prints were made by a process of imbibition or dye transfer printing – see page 100 (110 × 140 mm)*

Far right *Portrait of a girl, c. 1916, by Ives' Hicro process, described on page 101. The softness of detail is due to losses in the optical system of the Hicro camera (174 × 230 mm)*

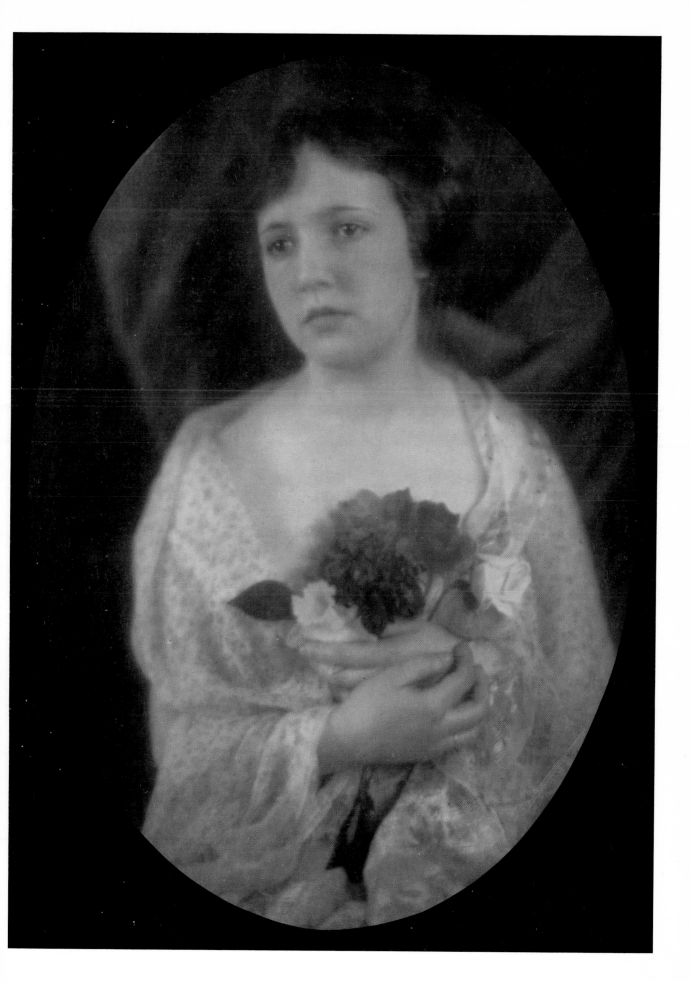

Above *R. Lechner's camera of 1912*

Below *The carbon process :*
A *An original subject represented by white, grey and black bands.* B *A negative made from the original is placed in contact with a bichromated gelatin 'tissue' and exposed to light. The gelatin hardens in proportion to the exposure.* C *The exposed tissue is attached to a transfer sheet 1, and soaking in lukewarm water detaches the original support 2.* D *Further washing removes the unhardened gelatin, producing a relief image.* E *If the carbon tissue does not already contain pigment, it can be dyed. Three reliefs, printed from separation negatives and dyed cyan, magenta and yellow, can be assembled in register.* F *Alternatively, the relief can be dyed and brought into contact with a receiving film or paper 3, to which the dye will transfer.* G *By this method of dye transfer or imbibition printing, three separation images can be printed in register from three relief matrices, which can be re-dyed and used again. The results can be seen on pages 90 and 91*

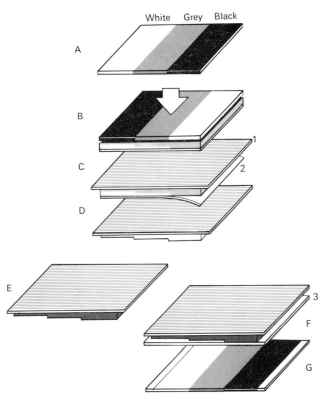

Germany. An advanced form of repeating back, rather like Ives' clockwork model mentioned in Chapter Two, was patented in 1930 by C. W. Oliver, for Colour Photography (British and Foreign) Ltd. A clockwork motor, working through a hydraulic device, moved the plateholder for the three exposures in a total time of three seconds. The ratio of the three exposures could be adjusted to allow for plates of different colour sensitivities, and the back was triggered by operating a cable release.

Separation negatives for the subtractive colour processes may be made also by combining the three films or plates into a single unit, the tripack, but we will consider this in the next chapter.

Before we consider some of the more important processes of printing in subtractive colours from separation negatives, we must consider a chemical process upon which so many of them were based. In May 1839 Mungo Ponton announced to the Royal Scottish Society of Arts that he had discovered that if a solution of potassium bichromate were applied to paper, and the paper exposed to light, it turned deep orange. By partly covering the sensitised paper with a leaf or similar object, Ponton was able to record its shape in white on an orange ground, and this image could be fixed by washing the bichromate from the paper. William Henry Fox Talbot discovered that if gelatin were treated with potassium bichromate it became light sensitive, hardening where light fell on it, in proportion to exposure, and becoming insoluble. Talbot published his discovery in a patent in 1852, dealing with its application to the production of printing plates.

In 1855 A. L. Poitevin patented a process in which a layer of bichromated gelatin containing powdered carbon was exposed under a negative. The exposed paper was 'developed' in warm water, which washed away the unhardened parts of the layer, to produce a positive. The intermediate tones of the picture were not well rendered, since the hardened top layer of the gelatin prevented the unhardened gelatin below from being washed away. Sir Joseph Wilson Swan improved this carbon process in 1864 by making the sensitive layer removable from its base. Swan's carbon tissues consisted of a gelatin coating containing pigment, supported on a paper base, sensitised just before use by soaking it in potassium bichromate. The dried tissue was exposed under a negative, and was then laid face down on a transfer paper. Soaking the two in lukewarm water caused

the tissue to detach from the original base, and the unhardened gelatin could then be washed away to reveal the image, in continuous tone. The tissues could be coloured by pigments of any colour, and the image produced was in relief – the dark parts of the picture were represented by a thick layer of gelatin, and the highlights by a thin layer. These two characteristics were to be very important in colour printing processes. The carbon process was used by many workers in the late 1890s and early 1900s for printing from separation negatives, on tissues coloured with cyan, magenta and yellow pigments, transferred in register on to a suitable base after 'development'.

A further development of the carbon process was based upon an observation by Howard Farmer in 1889 that bichromated gelatin brought into contact with finely divided silver hardened without exposure. In 1905 Thomas Manly patented his 'Ozobrome' process, in which a bichromated carbon tissue was squeegeed into contact with a print on bromide paper, in the presence of a silver bleaching agent. The tissue and the print were left in contact for a short time, during which the gelatin tissue hardened where it was in contact with the silver image, and in proportion to its density. The tissue was then 'developed' as usual for carbon tissues. The advantage of the Ozobrome process (or Carbro process – the trade name for the Autotype Company's version of the process in the 1920s and 1930s) was that daylight was not needed for printing, and enlarged prints could be made from the original negatives for larger colour prints. The bleached bromide prints could be redeveloped to make further copies.

Apart from the early experiments of Ducos du Hauron, the first successful three-colour printing process was demonstrated by Frederic E. Ives in 1888 at the Franklin Institute in Philadelphia. He had made prints on both paper and glass, but had more success with the latter. He made his prints from negatives made in a triple lens camera, or in succession with a conventional model. The red exposed negative was printed on a gelatin plate, the colour cyan being produced by the cyanotype or blue-print process. The green negative was printed on a magenta-pigmented carbon tissue, mounted in reverse on another glass plate. The blue negative was printed as a yellow-dyed gelatin relief image supported on a thin film of collodion, which was sandwiched between the two plates in register.

One of the first commercially applied sub-

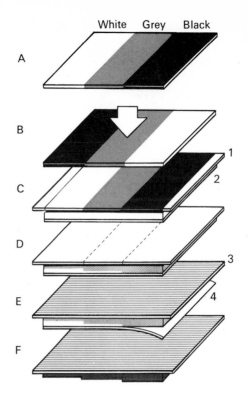

The carbro process:
A *The original subject, represented by white, grey and black bands.* B *A negative is made from the original.* C *The negative is printed or enlarged on to bromide paper 1. The processed bromide print is squeegeed into contact with a carbon tissue 2.* D *The silver image is bleached, and the tissue hardens in proportion to the strength of the silver image.*
E *The tissue is laid down on a transfer sheet 3, and washed to detach the original support 4.* F *Further washing 'develops' the relief image, which can be dyed if necessary, and assembled in register with other reliefs, or it can be used for imbibition printing.*

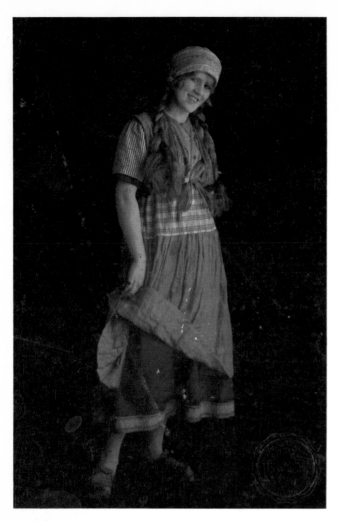

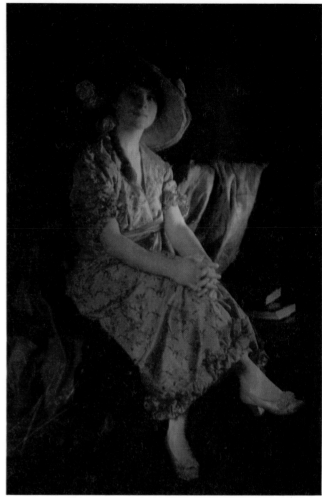

Above left *A Polychromide print made at the Dover Street Studios, London, c. 1913. Aaron Hamburger's process is described on page 104 (127 × 187 mm)*

Above *Lady in an orange dress, 1915. A two-colour Kodachrome transparency by the photographer Mock, of Rochester, New York (185 × 237 mm)*

Right *'Molly Mulligan', November 1914. An early two-colour Kodachrome transparency by the photographer Wills. For details of the process, see page 104 (170 × 220 mm)*

An advertisement from the British Journal of Photography Almanac *for 1936 for the Bermpohl colour camera*

tractive processes was introduced by the Lumière brothers in a patent of 1895. They used bichromated gelatin glue, with the addition of a small amount of silver bromide, coated on sheets of paper. The silver enhanced the relief produced, by the effect that Howard Farmer had observed. Three coated papers were exposed under three separation negatives, and the exposed tissues were transferred to glass supports for development and staining in the complementary colours, an operation which took about twelve hours. While still on the temporary supports, the three transparencies could be superimposed to check that the colour was correct, since some strengthening was possible at this stage. First, the yellow image was cemented to a sheet of paper with glue, followed by the cyan and then the magenta images. If a transparency was needed, the combined tissues could be finally transferred to glass from the paper. The Lumière brothers showed colour prints on paper at the Paris Exhibition of 1900, which, said an authority, had 'a richness of colouring and luminosity that far exceeded all previous work'.

E. Sanger-Shepherd's process, described in 1899, was similar to that of the Lumières, in using a bichromated gelatin film containing silver bromide. The gelatin was coated on celluloid films, exposed from the separation negatives through the back, and developed in warm water as usual. The magenta and yellow components were made in this way, but Sanger-Shepherd suggested that the cyan image be produced as a cyanotype toned image on a glass plate, serving as a cover glass when the three images were bound up in register and cemented together with Canada Balsam.

The Pinatype process, patented in France in 1903 by Leon Didier, was based upon a principle which had been known for many years. In 1874 E. Edwards had described a method of printing by dyeing a gelatin image, selectively hardened by the bichromate process, and bringing it into contact with a surface to which the dye would transfer. The harder the gelatin layer, the less dye it would retain and the less would be transferred. This form of printing, known first as hydrotypie, became known as imbibition or dye transfer printing. Charles Cros independently discovered the effect in 1880, and suggested that it might be used to transfer three dye images in register. However, Didier was the first to exploit the process commercially, from 1905. The glass printing plates were coated with bichromated gelatin and exposed under separation positives made from the original negatives. The exposed plates were washed to remove the bichromate

An outfit for the Pinatype colour printing process, 1905

sensitiser and were then dyed with the appropriate subtractive colours, the dyes taking up most in the unhardened areas. The prints were made on any gelatin-coated material; usually fixed-out bromide or chloride paper was used. The paper was soaked in water, squeegeed in contact with one of the dyed printing plates and left under pressure for about fifteen minutes. After the dye had transferred to the paper, the cyan image being usually the first, the magenta image could be transferred in register. The yellow image followed to complete the print. Transparencies could be made in the same way, by transferring the dye images to a gelatin-coated glass plate.

From 1906 Sanger-Shepherd adopted an imbibition printing process, using films coated with bichromate sensitised silver bromide emulsions. After exposure through the film base, the reliefs were developed in warm water, fixed, washed and dried. These reliefs were dyed and used to transfer the images to gelatin-coated paper, the yellow image being transferred last. In this case, the dye transferred in proportion to the thickness of the gelatin relief. The process suffered from the problem of the dye from the first transfer

wandering into the second 'plate', reducing the colour purity. Only the purest paper and expensive dyes were satisfactory. F. W. Donisthorpe's process of 1907 also used imbibition printing, but in his process the dyes were transferred from the original negatives, which had been treated with a bleach which removed the silver image and at the same time proportionally hardened the gelatin. The softer, less exposed parts would take up more dye, and could transfer it to a gelatin-coated paper. The transfers were made in the usual order – cyan, magenta and yellow.

F. E. Ives' process for printing the negatives produced in his Tripak camera of 1911 employed bichromated gelatin-coated films, dyed and registered after exposure and development, to make colour transparencies. An improved version, the Hicro process, was introduced in 1915. The three separation negatives from the Hicro-Universal camera, described above on page 88, were printed side by side on a special bichromated gelatin-coated film containing some silver bromide. After removal of protective varnish, the printed film was developed by suspending it in a bucket of warm water. The relief films were then fixed, cut up and dyed with the appropriate colour. When dry, the positives were assembled in register

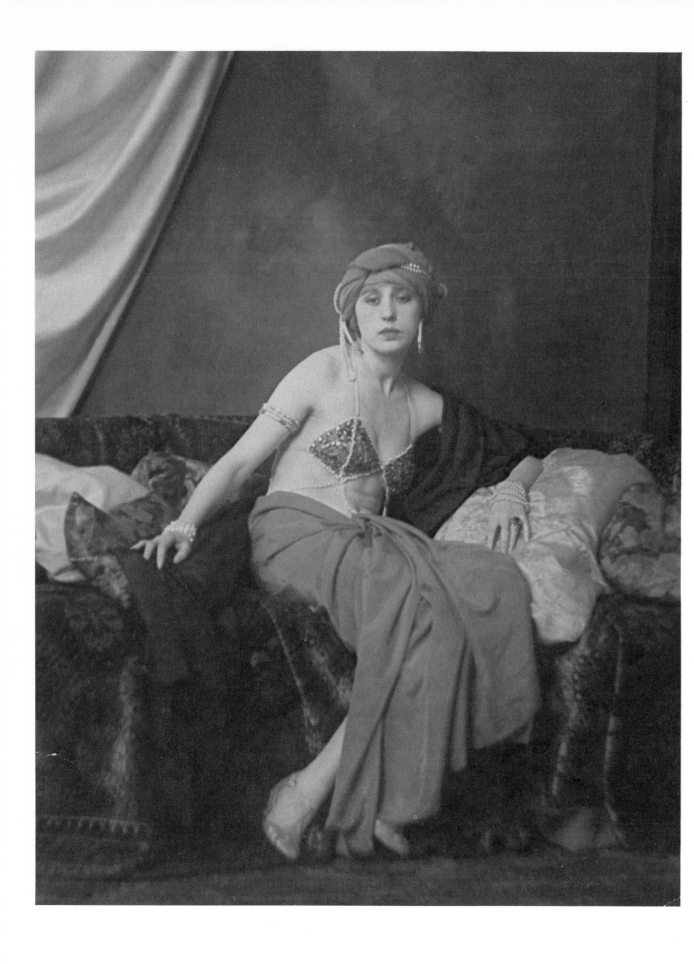

Far left *Oriental study; a Jos-Pe imbibition print, c. 1930.
The Jos-Pe process is described on page 105 (230 × 260 mm)*

Above left *Portrait of a blonde, by Herbert Lambert, 1932.
A Vivex print from negatives taken with the Vivex automatic
repeating back. See pages 96 and 109 (257 × 334 mm)*

Above *St Edward's crown, photographed at the Tower of
London in 1937 by Dr D. A. Spencer; a Vivex colour print
(285 × 376 mm)*

Left *The Honorable Marchese Marconi, 1934. A Vivex
portrait of the pioneer of radio (222 × 297 mm)*

*An early advertisement for the Raydex colour printing process,
from the* British Journal of Photography Almanac, *1914*

and bound between glass. To make prints on paper, the red exposed negative was printed on cyanotype paper, while the other two were printed as above, as films. The magenta film was registered with the cyan image on the paper, as was the yellow film. The whole was then securely clamped and immersed in amyl acetate for a few seconds, then run between blotting paper through a rubber roller press. As the instructions suggested, 'a clothes wringer will serve'. The three 'leaves' were thus firmly cemented together.

Aaron Hamburger's Polychromide process was operated from London's Dover Street Studios from 1911. Pfenniger's improved Bennetto camera was used to make the separation negatives, with high-intensity electric lights permitting exposures, it was claimed, as short as 1/100 second. The three prints from the negatives were made by different methods. The yellow image was printed on bromide paper, bleached and then chemically toned to form a metallic yellow image. The magenta print was made on suitably coloured carbon tissue, while the cyan image was a cyanotype toned silver image. The studio boasted

that eminent sitters for Polychromide portraits included Pavlova, Prince Alexander of Teck, Sir Joseph Lyons and the Gaekwar and Maharanee of Baroda. The process was operated until the First World War.

The Raydex colour process (1913) was the first of significance to use the Ozobrome or Carbro printing method. Raydex supplied pre-dyed sheets which were sensitised before use and brought into contact for some minutes with bromide prints made from the separation negatives. The prints were developed in hot water, and then assembled on a temporary support before transfer to the final support. The *British Journal of Photography* said, 'For the first time [Raydex] brings the production of three colour prints within the capacity of the ordinary amateur'.

An unusual process was unveiled on November 1, 1914 in Rochester, NY. The invention of J. G. Capstaff, of the Kodak Research Laboratory, the new process was based on two-colour reproduction, and was intended for professional portraiture. A pair of negatives was exposed, either simultaneously in a suitable camera, or in succession in a repeating back. One was taken through a red filter, the other through green. High intensity electric light, totalling 9,000 watts, was

recommended to illuminate the studio. The negatives were developed and washed, then bleached in a ferricyanide, bromide and bichromate bath, which, as it bleached the image, hardened the gelatin proportionally. After fixing and drying, the plates were dyed red-orange (from the green exposure) and blue-green (from the red exposure). The unhardened gelatin, where the negative image had *not* been, took up the dye to make a colour positive, and the two were bound face to face in register to make the transparency. Alternatively, duplicate negatives might be made from the originals, so that multiple copies could be made. The process was named Kodachrome, and although the two-colour analysis would not reproduce pure blues, purples or violets, it was very satisfactory for portraiture. Flesh tones in particular were very well reproduced. The process was introduced commercially from April 1915, and was available for some years.

The Jos-Pe process, the invention of G. Koppman, was introduced in 1924. It was yet another imbibition process, using films printed through the base, from the Jos-Pe camera or other negatives, and coated with a bichromated silver-bearing gelatin layer, giving a more pronounced relief than the print films of the Pinatype process. It remained a popular process for some time. The Jos-Pe process, like most of the others we have considered, was capable of producing good colour prints, but much skill, careful manipulation and considerable time were needed for success. These were severe limitations on commercial application by professional photographers. The professional could not expect a client to pay a realistic price for a colour print if it took hours of skilled work to produce. In the late 1920s the time was ripe for the appearance of a reliable colour printing process that the professional could use economically.

In 1928 a new company – Colour Photographs (British and Foreign) Ltd – was incorporated to develop a new colour process. The negatives were to be made by a tripack, which we will consider in the next chapter. It was proposed that the negatives be printed on to very thin coated cellulose films which were to be coloured by methods rather like those of the Polychromide process. The yellow film was coloured by metallic toning and the cyan by cyanotype toning. The magenta image was a dyed gelatin relief. The three were to be assembled on paper and cemented together. While the process worked, it suffered from all the old problems which inhibited economic commercial operation. When Dr D. A.

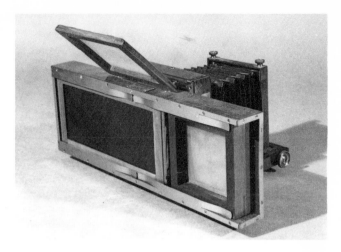

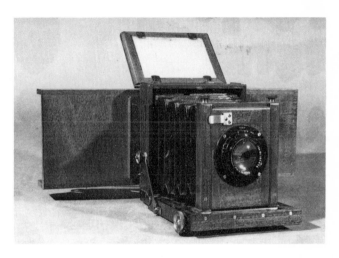

Above *The Sanger-Shepherd folding camera, 1905, fitted with the Sanger-Shepherd repeating back for colour work*

Below *The Sanger-Shepherd Colour Stereoscopic set, 1907. A repeating back is fitted to a box-form stereoscopic camera, with flap shutter*

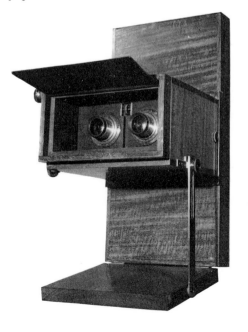

Portrait, by L. M. Condax and R. P. Speck, c. 1940.
Negatives taken with a Devin one-shot colour camera and
printed by the Eastman Wash-off relief process – see page 109
(250 × 310 mm)

Lady in red, by L. M. Condax and R. P. Speck, c. 1940.
An Eastman Wash-off relief print from a Kodachrome
Professional Film transparency (227 × 320 mm)

Spencer joined the company in 1928 he decided that the Carbro process offered the best hope of developing a standardised process. He developed an improved Carbro process which made use of thin Cellophane sheets as temporary supports for the tissues when they had been stripped from their base, which greatly facilitated their precise registration on the final support, which could be practically any glossy or matt surface. The key to the success of the process was total control and standardisation of all the elements. The negatives exposed by the customer, preferably with the repeating back described earlier, were processed by the company; they included a scale of neutral tones photographed at the same time as the subject. Measurement of these tones enabled the laboratory to make accurate exposures of the bromide prints used to make the positives. Voltage control of the enlarger lamps, and chemical and temperature control of the processing solutions helped to standardise the process. The *British Journal of Photography* described the company's Willesden factory as 'the first in any country to be solely used for a competent and prompt service in the making of prints from sets of colour-separation negatives'. From 1931, the new process was known as Vivex; colour prints of very high quality were supplied by the company until the outbreak of the Second World War in 1939.

The Trichrome Carbro process, using materials supplied by the Autotype Company, was very popular with amateur workers in the 1920s and 1930s. At the Royal Photographic Society's Exhibition of Colour Photography in 1931, 90% of the colour prints were made by this process. The Autotype Company also supplied materials for the Dyebro process, published in 1928 by Owen Wheeler. It used a combination of the Carbro and Pinatype processes. Bichromated tissues were squeegeed on to bromide prints in the usual way, and were then developed into relief images after being transferred to celluloid film supports. The reliefs were then dyed and used to transfer the dye images to the final print paper.

The German Duxochrome process, devised by Dr Herzog and Herr Mroz in 1929, used pre-dyed bichromated silver bromide emulsions on film supports, developed after exposure to relief images. The reliefs were transferred in turn to a paper

Above *An advertisement for the Colour Photographs company*

Left *The Jos-Pe process was widely used in the 1920s. See page 102*

The Vivex repeating back was devised and patented by C. W. Oliver in 1930. See page 103

support, the celluloid base being stripped off as each relief dried. The ever-inventive Frederic Ives came up with a two-colour process in 1932, which he called Polychrome. The pairs of negatives were made with bipacks – a blue and green sensitive plate in front, and a red sensitive plate behind, with a thin yellow filter between them – which could be exposed in an ordinary camera. Dupac sheet film and 35 mm film versions were also available. From the red negative a cyanotype blue print was made on paper, and a relief image was produced on film from the blue-green negative. A dichroic red dye was used to colour this, dyeing the thinner parts of the relief yellow and the thicker parts red. Ives claimed that this produced a wider range of colour than that normally found in two-colour work. The dyed film was cemented in register to the paper print. For quantities of prints, up to fifty copies, relief films could be prepared from both negatives and could be used to print by dye transfer on to a suitable support.

The Defender Photo Supply Company of America marketed materials for three-colour printing by the Chromatone process from 1935. Separation negatives were printed on to stripping bromide papers which after development were stripped from the base and chemically toned to produce the three subtractively coloured positives. Nickel compounds produced the magenta colour, cadmium the yellow and iron compounds the cyan colour. The toned, stripped emulsions were assembled in register on a gelatin-coated paper sheet, starting with the yellow and finishing with the cyan.

The last subtractive printing process of note to appear before the Second World War was the Eastman Wash-off Relief process, announced in 1935. It was essentially a refinement of the imbibition printing process. Relief positives were made on Wash-off Relief film from the separation negatives. The dyed positives were brought into contact with a fixed-out sheet of photographic paper, either matt or glossy, which had been wetted and laid down on a plate glass sheet, coated side up, and squeegeed under pressure to stretch it to the maximum. After transfer of the magenta dye image, which took ten to thirty minutes, preferably under pressure, the cyan image was transferred, a thin celluloid sheet being interposed between the paper and film while the latter was registered, and withdrawn just before squeegeeing down. The cyan transfer took about the same time as the magenta; finally the yellow dye image was transferred in the same way. The reliefs could be re-dyed and used to make more prints. By following the instructions precisely, the user could produce repeatable results with a consistency difficult to achieve with the earlier imbibition processes, in which the very flexibility of the process led to great variations between prints.

In 1946 the Wash-off Relief process was replaced by the Kodak Dye Transfer process, an improved form which made standardisation even easier, and yielded colour prints of high quality and permanence. With the exception of this process, virtually no other subtractive printing processes survived the Second World War; their role was taken over by the new integral tripack colour materials we shall consider in the next chapter.

5 Three into one *will* go

A Kodachrome film transparency, 1938. The Kodachrome process was the first of the modern colour materials – see page 124 (24 × 36 mm)

We saw in the last chapter that some colour processes used a bipack of two plates face to face to make two of the three necessary separation negatives. If a tripack was possible, combining all three sensitive surfaces, it would dispose of the need for more or less complicated optical systems within the camera – indeed, no special camera would be needed at all. As with so many other concepts in colour photography, Ducos du Hauron was the first to propose such a system, in a French patent of 1895. He suggested a multiple-layer package, starting at the top with a blue-sensitive virtually transparent emulsion, coated on a glass plate, which was placed glass towards the lens. Then came a very thin film, dyed yellow, which would prevent the further passage of blue light, but which would pass green and red. This was followed by a thin film coated with an emulsion sensitised for green, below which came another filter film, this time dyed red. Finally there was another plate, coated with a red-sensitive emulsion. Ducos du Hauron compared his package to a book, with two rigid glass 'covers' enclosing three flexible 'leaves'. A single exposure of the 'polyfolium chromodialytique' would analyse the scene in terms of the three primary colours. The various elements of the package could be separated for processing and printing.

Dr J. H. Smith of Zurich took this principle further in his German patent of 1903, proposing that to overcome the problems of achieving optical contact between the layers they should be coated one on top of the other on a single plate, with a film of collodion, dyed to form a filter of the appropriate colour, between the emulsions. After exposure, the top two emulsion layers could be stripped from the plate and transferred to new supports for

Agfa-Ansco Colorol prints, 1929. The process was similar to, but of better quality than, the English Colorsnap method described on this page (120 × 210 mm)

processing and printing by one of the usual methods. Smith's tripack never saw commercial use, although he did market a double-coated plate for two-colour work in 1906.

Ducos du Hauron's tripack was adopted in 1916 by Frederic E. Ives for his Hiblock system. A tripack of two plates on either side of a thin film was used. The front plate, exposed through the back, was coated with a transparent, blue-sensitive emulsion, the surface of which was coated with a thin film of yellow dye. The interleaved film was green-sensitive, and the final plate carried a red-sensitive emulsion. This tripack could be exposed in any plate camera, and the negatives were

separated for development. When processed, they were printed on to bichromated films to produce reliefs. The cyan-dyed film was used to print an image by dye transfer on to a support paper, and the magenta and yellow films were cemented in register upon the paper with amyl acetate.

The tripack system was adopted by an English company, Colour Snapshots (1928) Ltd. Their process was based on a patent by William Tarbin, who had observed that the problem of the traditional tripack arrangement was that the image which contributed most to the visual sharpness of the final print, the cyan image derived from the red exposure, was the most diffused, having been exposed through two other emulsions. The sharpest was the topmost exposure, which produced the yellow image which was the least critical in this respect. Tarbin therefore proposed

Top *Ducos du Hauron's 'polyfolium chromodialytique',
proposed in 1895; the top element was a blue sensitive plate A,
face downward. Next came a yellow filter film B, followed by
a green sensitive sheet film C, emulsion upwards. Then came
another, red, filter D and finally a red sensitive plate E,
emulsion upwards*

Above *The Colorsnap plate, 1929, was a simplified form of
the Ducos du Hauron 'polyfolium', with a thin film
sandwiched between two plates. The Colorsnap advertisement
right* in the British Journal of Photography Almanac
for 1929, made claims that were not to be fulfilled

to reverse the arrangment and place the red-
sensitive emulsion at the top of the pack with the
green-sensitive and blue-sensitive layers below.
The problem with this arrangement was that both
the red- and green-sensitive layers were also
responsive to blue light, which would have to pass
through both before reaching the layer in which it
should be recorded. Tarbin dismissed this problem
by proposing to place a yellow filter over the lens to
reduce the blue light reaching the upper layers of
the tripack, and then greatly increasing the blue
sensitivity of the bottom layer to compensate.
Despite the obvious theoretical objections to this
dubious arrangement, Colour Snapshots (1928)
Ltd was launched with a capital of £350,000, and
the full public issue of 750,000 shares was taken up
almost immediately.

The company issued three products based on
Tarbin's 'trifolium': Colorsnap plates, which used
the Ducos du Hauron arrangement of two plates
sandwiching a film; sheet films, with three films
sandwiched together; and rollfilms. The latter,
consisting of three thin films attached to a backing
paper, required a special kit of clear celluloid
sheets and a nickel pressure plate to keep the
tripack flat in the camera. It was claimed that the
'trifolium' combination had a speed of 200–250
H & D – the equivalent of about 10 ASA, allow-
ing snapshots in good light. The negatives were
printed by a dye transfer method from gelatin
reliefs – at a cost, the company claimed, of only two
and a half times that of an equal black and white
enlargement. A 120 size rollfilm for four exposures
cost 3s, developing each spool cost 1s, and postcard
size prints were 1s each.

A factory set up at Hendon was able to produce,
it was claimed, 6,000 finished 'Colorsnaps' a day.
It sounded too good to be true – and it was. The
British Journal of Photography reviewed the process
and reported: 'We would describe them, choosing
our words carefully, as exceedingly pleasing
renderings of the subjects. It would be possible to
pick holes as regards their fidelity of colour
rendering in certain respects. What we can
definitely say is that they are photographs in
colour, of pleasing character in themselves, and
broadly reproducing the colour scheme of the
original scenes'. The company said 'It was not
claimed to reproduce with fidelity the original
colours of Nature; all that was claimed for it was
that it reproduces colour in a form that is pleasing,
and that bears a definite relationship to the
original colours'. Dr D. A. Spencer has described
how the company ended up using girls to colour by

Above '*Tea on Stanmore Common, 20 May 1929*', a Colorsnap taken by R. E. Owen, FRPS. *The group consists of members of the newly formed Kodak Research Laboratory, and their friends. Evidence that much of the colour has been applied by hand can be seen in the illustration (87 × 136 mm)*

Right *Spitfire Pilot – 1939. One of a series of Kodachrome Professional Film transparencies taken for exhibition at the World's Fair in America (75 × 100 mm)*

Below *The merry-go-round – a Kodachrome Professional Film transparency, 1939. This was a sheet film version of the improved Kodachrome process, introduced in 1938, as described on pages 125 and 128 (75 × 100 mm)*

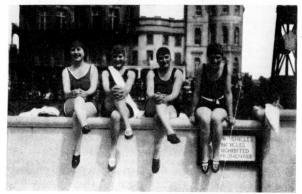

Colorsnap Film, a new and marvellous invention, enables you—the amateur photographer—to take snaps in *natural colours*

Here is a snapshot taken with an ordinary camera using Colorsnap film

Take it in colour! Load your camera in the usual way with a Colorsnap film. Take great care to see that your dealer has supplied you with a Colorsnap Pressure Plate. This keeps the film flat and ensures a good sharp picture.

Choose your subject with plenty of bright colour in it. Obviously, the most pleasing results will be achieved if your subject is a really

colourful one. Remember that Nature is greyer than you suppose it to be.

When you have exposed your spool of Colorsnap films, take it to an authorised Colorsnap Dealer and leave the rest to him.

Colorsnap is simplicity itself. A child can make pictures like the one printed here with an ordinary box camera.

Now take it in Colour!

Your dealer will tell you all about

COLORSNAP *film*

hand monochrome prints made from the sharpest, front element of the tripack, with the unfortunate result that one day they coloured a Post Office pillar-box in one scene bright red, to the concern of the customer who had taken the picture in Eire, where the pillar-boxes were bright green! Colour Snapshots (1928) Ltd went into compulsory liquidation in December 1929.

A more successful use was made of a version of this process, manufactured under licence from Colour Snapshots (Foreign) Ltd by Agfa-Ansco in the United States, under the name Colorol. The Colorol films, manufactured by Ansco, were of good quality, yielding very satisfactory colour prints. A roll of Colorol six-exposure film for $2\frac{1}{2} \times 4\frac{1}{4}$ inch (6.4 × 10.8 cm) negatives cost $2, including developing charges, the film being returned to the Agfa-Ansco works at Binghampton. The first 5 × 8 inch (12.7 × 20.3 cm) print from each negative set cost $2; subsequent reprints cost $1. The instruction book stated: 'due to the intricacy of the process by which these prints are made, we do not promise delivery under two weeks'. Amira AG of Germany produced a similar process in 1932, selling tripacks

in sheet film, film pack and rollfilm forms, requiring only three times the normal exposure for black and white films, it was claimed. The processed negatives were printed on to pre-dyed tissues, which were cemented together after development. A successful use of the tripack was made by Colour Photographs (British and Foreign) Ltd who in 1928 used a Ducos du Hauron type, consisting of three elements coated on film 3/1000 inch (0.08 mm) thick. The front, blue-sensitive film was arranged with the base towards the lens, with the green- and red-sensitive films face to face in intimate contact behind it. The tripack could be used with an exposure of around three seconds in incandescent studio lighting. The use of large format negatives for contact printing on to thin tissues, dyed and assembled in register, minimised the effects of loss of definition.

The problems inherent in all tripacks formed of separable elements are the great difficulty in obtaining complete optical contact between the various layers, and the effects of diffusion of the image passing through successive layers. Smith's three-layer plate appreciably reduced such losses, but it required that the layers be separated for processing and printing. The ideal would be an integral tripack, carrying three light-sensitive

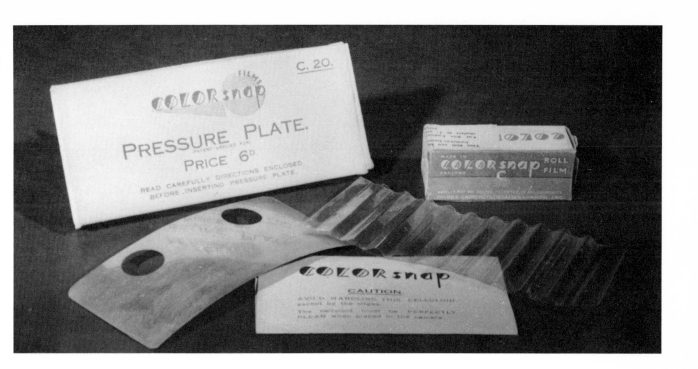

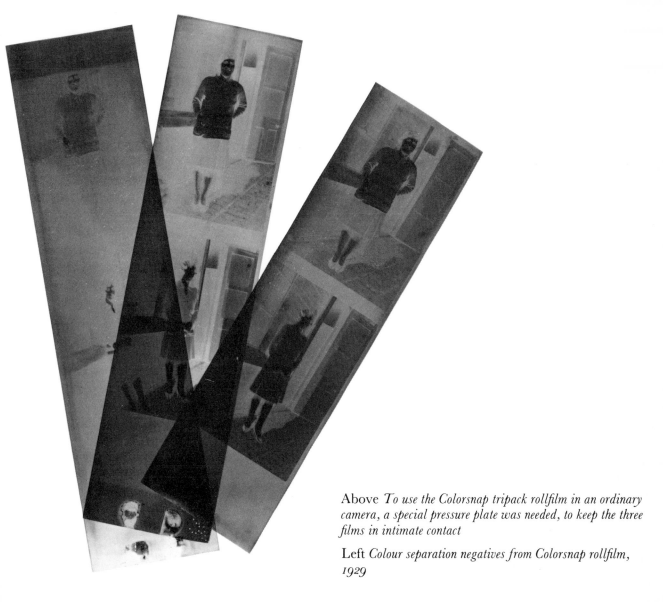

Above *To use the Colorsnap tripack rollfilm in an ordinary camera, a special pressure plate was needed, to keep the three films in intimate contact*

Left *Colour separation negatives from Colorsnap rollfilm, 1929*

Far left *Captain Clark Gable, photographed by J. C. A. Redhead, FRPS, while visiting the Kodak factory at Harrow in 1943. A Kodachrome Professional Film transparency (120 × 160 mm)*

Above *Manhattan Skyline, c. 1945. A Kodachrome Professional Film transparency (93 × 120 mm)*

Left *Yousef Karsh of Ottowa, a Kodachrome Professional Film transparency by J. C. A. Redhead, FRPS, c. 1944 (110 × 155 mm)*

Above *Leopold Godowsky, left, and Leopold Mannes, the professional musicians whose experiments in colour photography led to the introduction of Kodachrome film, the first integral tripack process*

Right *When Kodachrome film for still photography was introduced in 1936, it was returned from processing as a film strip. From 1938 a ready-mounting service was provided, and the transparencies were returned in card mounts*

layers coated on a single base, responding individually to red, green and blue light and capable of being processed to give complementary coloured images – cyan, magenta and yellow – in those three layers.

The first suggestion for such a process came from the Austrian Karl Schinzel in 1905. He proposed a plate coated with three emulsions. The top layer was to be sensitive to blue light, and would be dyed yellow. The middle layer should be red-sensitive, and be dyed cyan, while the bottom, green-sensitive layer would be dyed magenta. Schinzel proposed that the exposed plate would be processed to a black and white negative, and then treated with hydrogen peroxide solution. This, he hoped, would bleach the dye in the immediate vicinity of the silver image, and in proportion to it, thus producing a positive dye image in each layer. When the silver image was subsequently chemically removed, a colour transparency would result. Unfortunately, the process did not work effectively, since the peroxide solution did not work selectively, bleaching out the dye not adjacent to the image as well. Nonetheless, Schinzel's

proposed 'Katachromie' process did outline the principle of an integral tripack process, and the idea of producing an image by a process of dye destruction did reach a commercial application later.

In 1912 the German Rudolph Fischer was granted a patent which included a proposal that 'three positives may be obtained in one operation by the use of three superposed emulsion layers sensitised for the particular colours, and in which the substances necessary for the formation of the colours are incorporated. Intermediate colourless insulating layers are preferably used to prevent diffusion of the colours, and a yellow filter layer is used to reduce the sensitiveness to blue of the red and green layers'. The colour-forming materials referred to had been investigated in 1907 by B. Homolka, who had shown that certain substances which could act as or react with developing agents were converted into dyes as development took place. Fischer suggested that such substances, capable of forming cyan, magenta and yellow dyes, should be incorporated in the appropriate layers so that when treated with a suitable developing agent these couplers, as they became known, would react to form dye images in proportion to the silver formed during development. Fischer's integral tripack was completely sound in theory, but it was not capable, at the time, of being manufactured

satisfactorily. The coupler materials were inclined to wander from layer to layer during processing, destroying the purity of the colour rendering. For the time being, the process remained a theoretical possibility only, although Fischer, with H. Siegrist, did market in 1914 a colour toning paper for monochrome prints which incorporated the colour couplers.

In the early 1920s two young Harvard graduates were experimenting with the preparation of colour plates. Both were accomplished professional musicians: Leopold Mannes, a pianist, and Leo Godowsky, Jr, a violinist. One of their early processes, patented in 1924, was for a two-colour method using a plate coated with two emulsion layers. The upper one was a slow emulsion, sensitised to blue and green light, while the bottom layer was a faster red-sensitive emulsion. The top layer was dyed yellow to prevent blue light from reaching the bottom layer. The speeds of the two layers were adjusted so that both were correctly exposed by a single exposure. They suggested several ways of developing a colour image, the most significant of which involved the use of a developer which would act on the upper layer only, not penetrating to the bottom layer before development was complete in the layer above. This allowed the silver image in the upper layer to be bleached and toned blue-green, and then the

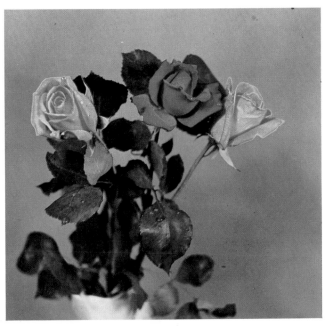

Top *Paris, 1937 – an Agfacolor Neue transparency reproduced as a Vivex print, by Dr D. A. Spencer. The new Agfacolor film was introduced in late 1936 – see page 128 (144 × 207 mm print, from 24 × 36 mm original)*

Top left *Young fishermen, Paris, c. 1937. A Vivex print from an Agfacolor Neue film transparency (202 × 290 mm print from 24 × 36 mm transparency)*

Left *Roses – a Gasparcolor film transparency, c. 1934, printed from separation positives. Gasparcolor was the first successful silver dye-bleach process, described on page 131 (70 × 75 mm)*

Bottom left *Christmas 1943 – German children playing Halma. An Agfacolor Neue film transparency (24 × 36 mm)*

Above *A Berlin street, c. 1938, photographed on Agfacolor Neue film (24 × 36 mm)*

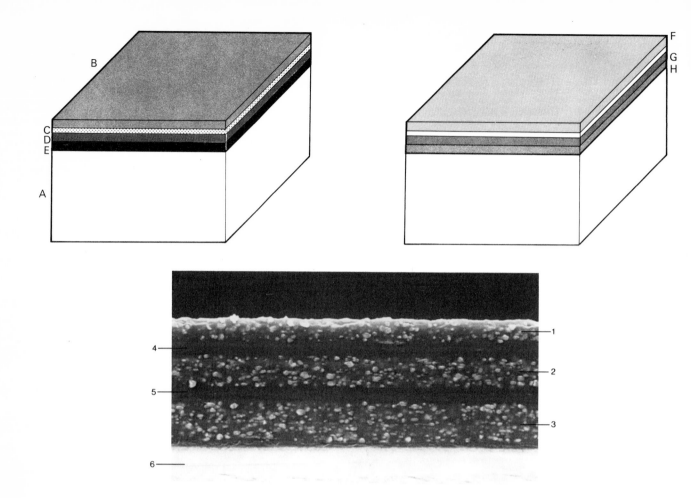

Top *Kodachrome film. The integral tripack film consists of a film base A coated with three very thin emulsion layers. The upper layer B is sensitive to blue light; a yellow filter layer C below it prevents blue light from reaching the layers below. The middle emulsion layer D is sensitised to respond to green light and the bottom layer E to red light. After exposure and processing, the upper layer carries a yellow dye image F, the middle layer a magenta image G and the bottom layer a cyan image H. Most colour processes today still follow these principles, but differ in the chemical processes involved.*

Above *A scanning electron micrograph of the edge of a Kodachrome film of 1936, magnified 1,700 times. The three emulsion layers, 1, 2 and 3, with their silver halide crystals, can be seen clearly. The yellow filter layer 4 and a clear gelatin interlayer 5 separate the emulsions. The top only of the film base 6 is shown; at this magnification the film would be nearly five feet thick!*

Above right *The Kodachrome film process 1935–1938:*
A *The original subject, represented by red, yellow, white and black bands.* B *The upper layer is exposed by a white light, the middle by yellow and white, and the bottom layer by the red.* C *The first black and white developer produces a negative silver image.* D *The silver image is bleached from the film, together with the yellow filter layer.* E *The film is redeveloped*

in a cyan colour-forming developer giving a silver and a cyan dye image in each layer. F *A controlled penetration bleaching solution removes the images from the top two layers.* G *These two layers are redeveloped in a magenta dye-forming developer.* H *The silver and dye images are removed by controlled bleaching from the top layer.* I *The top layer is redeveloped in a yellow dye-forming developer.* J *The silver images are removed chemically, leaving the three dye images only, reproducing the original colours.*
An example appears on page 110

Right *The Kodachrome film process from 1938:*
A *The original subject, as above.* B *The three layers exposed.* C *The film is given a black and white development, giving negative silver images in all three layers.* D *The film is then re-exposed through the base to a red light, exposing the bottom, red-sensitive layer only, followed by a development in a cyan dye-forming developer.* E *The film is re-exposed from the top to a blue light, exposing the top layer only, which is then developed in a yellow dye-forming developer.* F *A magenta colour-forming developer then is used to produce a magenta dye and silver image in the middle layer.* G *The negative and positive silver images, together with the yellow filter layer are bleached away, leaving three positive dye images in the film.*
See examples on pages 114–15 and 118–19

124

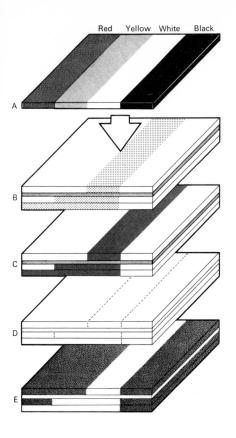

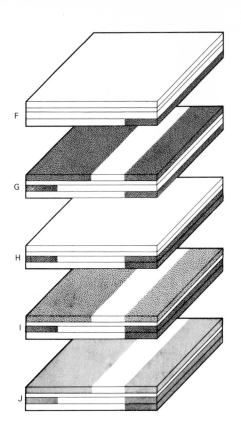

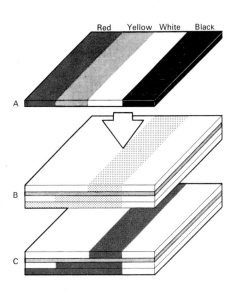

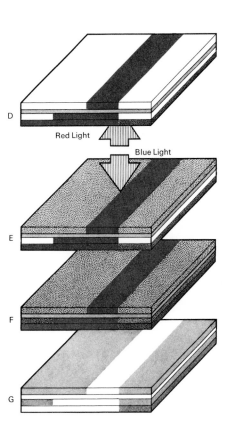

Right *Autumn landscape,
c. 1943. A Kotavachrome
print, on white opaque film
base, printed from a
Kodachrome Professional
Film transparency
(350 × 270 mm)*

Below *Minicolor prints, in
two sizes, were available in
the United States from 1941,
printed on white opaque film
base from Kodachrome
transparencies (136 ×
196 mm and 55 × 80 mm)*

Far right *Wedding party –
a Kotavachrome print from a
Kodachrome Professional
Film transparency, c. 1942
(268 × 340 mm)*

bottom layer could be developed and dye-toned orange-red. Alternatively, both layers could be developed together, and the images bleached, and a controlled penetration toning solution applied so as to tone only the upper layer, the bottom layer being subsequently dye-toned as before. Although as it stood this process was not very practical, it was to evolve into an important commercial process.

In 1922 Mannes and Godowsky had been introduced to Dr C. E. Kenneth Mees, the English Director of Research for the Eastman Kodak Company in Rochester, NY. Through his good offices, the Kodak Research Laboratory coated many experimental plates for the two amateur researchers. They discovered that a major problem with multilayer emulsions was that the dyes used to sensitise them for various colours would wander through the layers, making the red-sensitive layer slightly green-sensitive, and vice versa. In 1928 the Kodak Research Laboratory discovered a new range of sensitising dyes, some of them much less mobile than their predecessors. In 1930 Mannes and Godowsky were invited to join the staff of the Kodak Research Laboratory, where they concentrated on methods of processing multilayer films, while their colleagues worked out ways of manufacturing them. The result was the new Kodachrome film, launched in 1935. Three very thin emulsion layers were coated on film base, the emulsions being sensitised with non-wandering dyes to red, green and blue light, the red-sensitive layer being at the bottom. To deal with the unwanted blue sensitivity of the red and green layers, a yellow filter layer was provided below the top coating and above the bottom two. A single exposure produced a record of the red, green and blue content of the scene in the three layers. The exposed film was first developed to give a negative silver image in the three layers, the silver then being chemically bleached out, together with the yellow filter layer, which was a form of very finely divided silver. The film was then re-exposed to light, and all the remaining silver salts were developed in a solution containing the colour-forming couplers to produce positive cyan dye images in all three layers. Next, a bleaching solution, the penetration of which could be accurately controlled, was applied to the film until the cyan dye in the top two layers was removed, but leaving that in the bottom layer intact. The bleaching solution also converted the silver image in the top two layers back into developable silver bromide. A second colour development followed, using a magenta coupler, to produce a magenta

dye image in the top two layers. Another bleaching stage removed the magenta dye from the top layer, which was then redeveloped in a yellow dye-forming developer. Now, the film had positive images in both silver and dye in each layer. The silver was removed by bleaching, leaving three clear dye images only.

The new process was released first in the form of 16 mm movie film, announced in April 1935. 8 mm movie film followed in May 1936, and 35 mm and 828 size films for still photography were released in September 1936. Because of the very complex processing involved, the Kodachrome films had to be returned to the manufacturer for processing, and the film was sold with the cost of development included. The new Kodachrome film was sensitive enough to permit exposures of 1/30 second at f/8 in good light. It sold for 12s 6d for an eighteen-exposure film, including the cost of processing, which compared not unfavourably with the cost of a black and white film together with developing and printing charges. At first the films were returned in an uncut strip, for the customer to mount as slides, or to project in a film strip projector. In February 1938 a ready-mounting service was announced and the transparencies were returned to the customer in 2 × 2 inch (5 × 5 cm) card mounts. The Kodachrome film was the first commercial integral tripack film, and with its great transparency favourably contrasted with the rather dense additive screen plates and films. However, the processing cycle was very complex, and the stability of the dyes was not very good.

Both problems were resolved with the introduction of an improved process in 1938. The film, of the same construction as before, was first developed to a black and white negative. Then, the film was re-exposed through the back to a red light, which affected only the bottom layer, which was then developed in a cyan dye-forming developer. Then the film was re-exposed from the top to blue light, and the top layer was developed in a yellow dye-forming developer. Finally, a magenta dye-forming developer, containing a chemical fogging agent, was used to develop the middle layer. Now, the film had both negative and positive images in silver in each layer, and positive dye images. It remained only to bleach out the silver images, and the yellow filter layer, and a colour transparency of dye images only was left. The basis of the Kodachrome film process has remained unchanged ever since. The improved process was still complex enough that the processing of the film could only be carried out by the manufacturer, or

by a laboratory equipped with the necessary complex machinery. In November 1938 the new process was made available also in sheet film form as Kodachrome Professional film, in sizes from $3\frac{1}{4} \times 4\frac{1}{4}$ inches (8.25 × 10.8 cm) to 8 × 10 inches (20.3 × 25.4 cm). Later, the range was extended, offering sizes from $2\frac{1}{4} \times 3\frac{1}{4}$ inches (6 × 9 cm) to 11 × 14 inches (28 × 35.5 cm). Kodachrome Professional film remained on the market until 1951, when it was superseded by Kodak Ektachrome film, introduced in 1946, which could be processed by the professional user.

The Agfa company in Germany had been involved, as we have seen, for many years in the manufacture of Agfacolor screen plates. Late in 1936 they announced a new product: Agfacolor Neue. The new film was a commercial realisation of Fischer's integral tripack principle. The three-layer construction was similar to that of the Kodachrome film, but in the Agfa product the colour couplers were incorporated in the emulsion layers. G. Willmans of the Agfa Research Laboratory discovered a method of overcoming the problem of the couplers wandering during the processing operations. He made the coupler molecules very large, so that while they would mix readily in the liquid emulsion during manufacture, once the gelatin had set they were trapped in the minute spaces of its spongy structure. Dr Heinz Berger has compared the result with the problem of trying to carry a large tree through a dense forest. After the three-layer film had been exposed, it was developed first in a black and white negative developer, and then in a colour-forming developer which reacted with the couplers in each layer to form, simultaneously, cyan, magenta and yellow dyes. When the negative and positive silver images were bleached away, a pure dye image was left. Agfacolor Neue films were released first as 16 mm movie films and in 35 mm still form. At first, the films were returned to Agfa for processing, but the inherently simple process made development by the user possible in later years.

Although released at first as a reversal transparency film, during the Second World War Agfacolor underwent several changes. A negative-positive version was developed for professional motion picture use in 1940; the camera film was given a single colour development to give a negative in colours complementary to the original. The negative was printed on to a tripack positive film, also given a single colour development to produce a positive print. Small-scale production of colour paper for printing from Agfacolor negatives

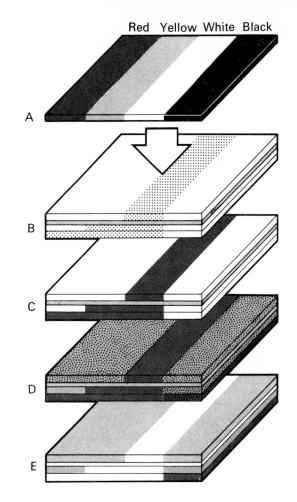

Red Yellow White Black

The Agfacolor film process, 1936:
A *The original subject of red, yellow, white and black bands.* B *Each layer is exposed appropriately.* C *A black and white developer produces negative silver images in all three layers.* D *A single colour developer produces silver and dye images simultaneously in all three layers, which carry the colour couplers in the emulsions.* E *The negative and positive silver images are bleached away to leave dye images only in each layer.*
See examples on pages 122–3

began in 1942, but this material did not become generally available until 1949. At the end of the war information about Agfa's manufacturing processes became freely available, and many of the post-war colour processes were based upon the Agfa principles.

A process almost identical to Agfacolor was announced by the Ansco company in America in 1942. Ansco had been associated with Agfa before the war; their new process was produced at first for military use only, and despite occasional public showings of the results no supplies for the general public were forthcoming until the end of the war. A reversal print process, using the tripack construction coated on a white plastic base, was developed by Ansco during the war under the

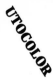
An advertisement for Dr Smith's improved Utocolor printing paper of 1911 which produced colour prints from colour transparencies by a bleaching-out process

name Ansco Printon, but only limited supplies were available until after the end of hostilities.

As a result of a demand from the US Army Air Force for a colour material which could be processed in the field, the Eastman Kodak Company in 1940 developed a new version of the Fischer type integral tripack. They solved the problem of wandering couplers by dissolving them in organic solvents which were dispersed in the form of minute oily globules in the emulsion. The film was coated with the familiar three layers and yellow filter, and then developed with a colour developer; dyes were formed in all three layers simultaneously, as the breakdown products of the developer, produced as the silver image was formed, reached the adjacent oily globules, penetrated them and reacted with the couplers.

The first products using this new technique were colour films for military aerial photography, but in 1942 Kodacolor film was launched on the American market. The exposed film was given a single colour development to form a complementary coloured negative. This could be printed on to paper coated with a three-layer emulsion, developed to a colour positive. This was the first of the modern negative-positive processes to reach the public, and is still available, although the process has undergone several major improvements. Most notable of these was based upon the discovery by Dr W. T. Hanson of a method of compensating for the deficiencies of the dyes of the negative film by making the couplers themselves coloured. The coloured couplers not converted into image dye during processing remain in the film and by a process known as masking largely correct for the inadequacy of the negative image dyes when the prints are made. The improved Kodacolor film with the coloured coupler masking was introduced in 1949; today, virtually all colour negative materials make use of Dr Hanson's discovery. A reversal version of the original aerial photography film was introduced in 1946 as Ektachrome sheet film for professional users. This too is still on the market, in a variety of forms.

In 1941 the Eastman Kodak Company in America introduced a service for providing prints from Kodachrome transparencies. The new material consisted of three emulsion layers very similar to those of the Kodachrome film, but coated on a white opaque film base. Two versions were available. Minicolor prints, in two sizes – $2\frac{1}{4} \times 3$ inches (6×9 cm) and $5 \times 7\frac{1}{2}$ inches (12.7×19 cm) – were made from amateur 35 mm colour transparencies. (The name of this service was changed to Kodachrome Prints in 1946.) Kotavachrome prints were made from Kodachrome Professional sheet film transparencies, in sizes from 8×10 inches (20.3×25.4 cm) to 30×40 inches (76.2×102 cm).

Virtually all the subtractive processes so far considered have produced a coloured image by building up coloured dyes during development. On the other hand, we have seen that an alternative method might be to start with all dyes present, and destroy those that were not needed to form the image, as Schinzel suggested. The earliest attempts at bleach-out processes were based on the Grotthaus-Draper law, which when applied to dyes states that a dye will fade when exposed to light of a complementary colour. For example, a yellow dye will fade if exposed to blue or ultra-

violet illumination, which it strongly absorbs, while red light will fade a cyan dye. Dr J. H. Smith created a process in which fugitive dyes in the subtractive colours cyan, magenta and yellow were mixed and applied to paper in a gelatin coating which also contained a sensitising agent which accelerated the effect of light. When exposed under a transparent coloured object the dyes bleached in proportion to the colours present. For example, red light passing through the object bleached out the cyan dye, leaving the magenta and yellow dyes, forming red. Smith's Uto paper was introduced in 1904; in its first form the paper had to be treated with hydrogen peroxide just before use. An improved form, which came out in late 1906, was ready for use without treatment; the paper, which was almost black to start with, could give striking accuracy when printed under a coloured transparent painting. After exposure, which was of the order of ten to fifteen minutes in sunshine, the paper's sensitivity was reduced, although not entirely removed, by washing it with benzole, or a special Uto bath. The results were fairly stable; after ten hours' exposure to room light the print would show slight fading. Smiths improved the process again in 1911, renaming it Utocolor. The much more sensitive paper was intended to make prints from Autochrome and other transparencies. The process had limited commercial success; the two hours or more exposure in strong sunshine needed to print an Autochrome transparency not only bleached the paper, but the transparency too! The paper would not give a clean white, and the sensitising compounds gave it a strong, even unpleasant, smell. Fixing, while good, was not perfect, and the prints could only be kept in albums.

Utocolor paper was not, of course, made by the tripack principle, but we have seen that Schinzel had suggested such a film using dye destruction to form the image. This principle was taken up by the Hungarian chemist Dr Bela Gaspar in the early 1930s. The Gasparcolor process was announced in 1933 as a print film for colour motion-picture work, printed from colour separation positives. The film was coated with two layers on one side, and a single layer on the other. The two outer layers were coloured magenta and cyan, and that in the centre was dyed yellow. During development, the dyes were destroyed in proportion to the exposure, and a saturated transparent coloured image was produced. A version of the process for still transparencies and a modified form for prints on paper were announced in 1933, but no

The silver dye-bleach principle:
A *The original subject, of red, yellow, white and black bands.*
B *The exposed film, which contains yellow, magenta and cyan dyes in its three layers.* C *Black and white development produces a negative silver image in each layer.* D *The silver images are bleached away, the dye being destroyed in proportion, leaving positive dye images in each layer. Gasparcolor was the first successful silver dye-bleach process. An example of the results is reproduced on page 122*

significant commercial use was made of them, although the motion picture version did enjoy some use in the cinema, mostly for animated film work. An alternative version of the Gasparcolor process was proposed, in which the three dye-containing layers were coated on a white opaque film base, to be used for printing from transparencies. This was used by the US armed forces during the Second World War, but no commercial application followed until the post-war years, when it formed the basis of the Cibachrome colour printing process, which uses the silver-dye-bleach principle.

Postscript

Although there has been a great proliferation of colour processes since the end of the Second World War, for the most part these have been based upon principles introduced in the 1930s and 1940s. The Sakura Natural Color film, introduced by the Japanese Konishiroku company in 1940, used the method of processing with coupler-containing developers first used in the improved Kodachrome film process of 1938. It was on the market only for a short time, but was reintroduced as Sakuracolor in 1947. After 1960 Sakuracolor became an Agfa-type process, with the couplers incorporated in the emulsion layers. In 1972 the process was changed again to one of an Ektachrome film type. Fujicolor film, introduced in Japan in 1948 used a Kodachrome film type of coupler-in-developer process, remaining in this form until 1963. In America, the Dynacolor film, marketed from 1949, also used this principle; it remained on sale (called Dynachrome after 1959) until 1970. The English company Ilford Ltd produced a Kodachrome film type process under the name Ilford Colour Film from 1948 to 1960. It was renamed Ilfachrome from 1960 to 1962, then became Ilfochrome from 1962 to 1965. It was finally renamed Ilford Colorslide film in 1965, and remained on the market until 1968. Today, Kodachrome film, which has undergone several improvements, remains as the only surviving still photographic process in which the colour couplers are carried in the developers, a method which requires a complex processing arrangement but which produces transparencies of high resolution and consistent quality.

At the end of the Second World War, in 1945, the manufacturing methods and patented processes of the Agfa company were made generally available, and a number of companies made use of the principle of incorporating non-wandering large molecule colour couplers in the emulsion layers. We have already mentioned the Ansco Color film announced in 1942; this became available to the American public after the war. After 1955 the film was known as Anscochrome; it appeared in several versions, including a high-speed version, Super Anscochrome, sold in 1957. The Italian Ferrania company had introduced an Agfa-type colour film for a short time in 1942; it was reintroduced in 1947, but did not become generally available until 1951. Ferraniacolor film became 3M Color Slide film in 1969. The Belgian Gevaert company produced their version of the Agfa process in 1947; Gevacolor transparency film remained on the market until the company merged with Agfa in 1964. Other films using the Agfa principle have been produced in East Germany (Orwocolor, since 1964), the Soviet Union (ZO reversal colour film, since 1949) and Japan (Sakuracolor, from 1960, and Fujicolor R100, since 1961). Agfa, of course, have continued to develop and improve their Agfacolor films in their own right.

The Eastman Kodak Company's Ektachrome film, introduced in 1946, used the principle of immobilising the water-insoluble couplers by dispersing them in oily droplets in the emulsion layers. It has remained available in several forms including the High Speed Ektachrome film introduced in 1959, and in sheet, roll and 35 mm film types. Other films using the Ektachrome film principle have included the Fujichrome and Fujicolor films made since 1961. In addition to these transparency materials, most manufacturers have produced also negative-positive versions of their processes. The introduction of coloured coupler automatic masking in the improved Kodacolor film of 1949 has been followed in recent years by the products of other manufacturers using the same or similar principles in their negative films. Most of today's negative colour films and colour papers are compatible with each other, using the same processing arrangements.

The silver dye-bleach principle introduced by Dr Bela Gaspar in the 1930s was taken up by several manufacturers. The Eastman Kodak Azochrome process, introduced in 1940, was not used on a commercial scale. In 1953 Ilford Ltd introduced the Ilford Colour Print process, producing colour prints, on a white opaque film base, from colour transparencies. The process was renamed Ilfachrome Print in 1960. The now widely used Swiss Cibachrome Print colour material, using the silver dye-bleach process was first introduced in 1963, when for a time it was also

known as Cilchrome Print. Agfa-Gevaert employed the silver dye-bleach principle in their Agfachrome CU 410 colour print material from 1970 to 1976.

While the postwar colour materials for the most part do not embody any fundamentally new principles, their quality and versatility have been greatly improved. This is especially true of the colour negative-colour print processes. The most recent development has been the introduction of high-speed colour negative films (with ASA speed of 400) by Eastman Kodak Company, Fuji and Sakura. These new materials are over 2,000 times more sensitive than the Lumière Autochrome plates of 1907. The greatly improved negative-positive colour materials have now largely replaced the manipulative printing processes, such as Kodak Dye Transfer, in professional usage.

The colour processes which at first sight would appear to be different from the conventional materials discussed so far are the instant picture systems. Yet, they are still based upon the three-colour subtractive reproduction principle. The first of these materials was the Polaroid Corporation's Polacolor film introduced in 1963. The exposed multilayer negative film was drawn from the Polaroid Land camera in close contact with a positive receiving unit. A viscous developer was spread between them by this action; as it penetrated and developed the three negative film layers, subtractively coloured dye molecules were released in inverse proportion to exposure. The dyes migrated through the developer layer to a clear gelatin layer on the receiving unit to form a full colour image. The later SX-70 instant picture process, introduced by Polaroid in 1972, combines the negative and positive materials in a single picture unit containing fourteen coatings. The negative exposure is made through a transparent receiving layer, beneath which are the blue, green and red sensitive layers, each with an adjacent layer containing yellow, magenta and cyan metallic dyes combined with developing agents. As the exposed unit emerges through rollers from the camera, a reagent mixed with a dense black dye and white titanium dioxide is spread between the receiving layer and the negative layers. The black dye excludes light, allowing the negative layers to develop without fogging. As it develops, each layer releases dye from the adjacent layer, in inverse proportion to the exposure, the dyes migrating through the reagent into the receiving layer. The black dye is decolourised at the end of the operation, showing the full colour dye image against the white titanium dioxide layer. The image is laterally reversed, as in a mirror, and therefore a mirror is required in the light path in the camera to compensate for this.

The Eastman Kodak Company's PR-10 instant print film, first marketed in 1976, has a nineteen-layer structure in a single sealed unit. As the exposed unit emerges from the camera rollers, a black opaque activator is spread over the exposed three-colour separation layers at the front of the unit, which develop in a single reversal development to produce positive subtractive dye images which migrate through a black light-excluding layer, and then through a white 'backing' layer into a transparent receiving layer at the back of the unit. Thus, no mirror is required in the camera, since the image is the right way round. Although these modern instant picture materials have more complex structures and use somewhat different chemistry from conventional colour materials, they still employ the same fundamental principles.

Chronology

1810 Seebeck experiments with recording of spectra on moist silver chloride.

1839 Publication by Daguerre and Talbot of first practical photographic processes.
Discovery by Ponton of light action on bichromated paper.

1840 Herschel confirms and extends Seebeck's experiments.

1848 Becquerel records spectra on silver chloride coated silver plates.

1851 'Hillotype' process claimed to produce direct colour photographs; later revealed as a hoax.

1852 Talbot patents process using bichromated gelatin. ·

1855 Clerk Maxwell publishes theory of three-colour photography.
Poitevin publishes carbon printing process based on bichromated gelatin.

1861 Clerk Maxwell demonstrates the first colour photograph, by three-colour projection.

1862 Ducos Du Hauron privately communicates several methods of colour photography.

1864 J. W. Swan publishes an improved, practical carbon print process.

1865 Poitevin records colour images on silver chloride paper.

1868 Zenker proposes theory of light 'standing waves'.
Du Hauron patents several colour processes.

1869 Du Hauron publishes details of additive and subtractive colour processes.
C. Cros publishes theories of several colour processes.

1873 Dr Vogel discovers dye sensitising to green light of photographic materials.
Edwards describes principle of dye transfer printing.

1880 Cros describes method of 'hydrotypie' or dye transfer printing.

1882 First commercial orthochromatic plates sold.

1884 Vogel discovers dyes which sensitise plates for orange as well as green and blue.

1888 Ives demonstrates his colour process.

1889 Wiener confirms Zenker's theory of standing waves.

1891 Lippman demonstrates interference colour photographs based on Zenker's theory.

1892 McDonough patents method for production of colour mosaic filter screen by dusting on powdered colours.

1892–3 Ives demonstrates several additive viewing and projection devices.

1894 Joly patents process for production of colour line screens.

1895 Joly Natural Colour Process introduced commercially.
Du Hauron patents 'polyfolium chromo-dialytique' tripack.
Lumières patent 'bichromated glue' subtractive process.
Lanchester patents micro-prismatic dispersion process.
Ives demonstrates improved Kromskop viewers.

1896 McDonough patents colour line screen process.

1897 McDonough process on market.
J. W. Bennetto patents colour camera.
E. T. Butler patents colour camera.

1899 Kromaz additive viewer patented.
Sanger-Shepherd colour print process introduced.

1900 Lumières demonstrate 'bichromated glue' colour photographs.

1902 Sanger-Shepherd colour camera marketed.

1903 Didier patents Pinatype process.

1904 Krayn patents method of producing colour line screens by sectioning stacked sheets of coloured celluloid.
Smith's Uto colour paper sold.
Lumière brothers announce dyed starch grain colour process under development.

1905 Butler patents improved colour camera.
Powrie patent for line screen process.
Schinzel proposes integral tripack film.
Manly publishes Ozobrome printing process.
Pinatype process introduced.

1906 First fully panchromatic, commercial plates sold by Wratten and Wainwright.
Clare L. Finlay's patent for regular screen plate process.
Sanger-Shepherd dye transfer printing process introduced.
Improved Uto paper sold.

1907 Lumière Autochrome plates marketed.
Warner-Powrie line screen process announced.
Krayn line screen process demonstrated.
Omnicolore regular screen plates introduced by du Hauron and de Bercegol.
Sanger-Shepherd stereoscopic colour camera introduced.
Donisthorpe dye transfer printing process introduced.

1908 Thames Screen plates sold.
Dufay Diopticolor process announced.
J. H. Christensen patents irregular screen plate process.

1909 Thames 'Combined' plates sold.
Dufay Dioptichrome plates announced.
Fenske Aurora colour plates introduced.
Veracolor plates introduced.
R. Berthon patents lenticular film process.

1910 Ives' Tripack camera announced.
Dufay Dioptichrome 'combined' plates introduced.

1911 Krayn negative-positive screen film process introduced by NPG.
Polychromide process operated in London.
Utocolor paper introduced.

1912 Agfa experimental plates, based on Christensen's patent, demonstrated.
Improved Dufay Dioptichrome plates.

G. S. Whitfield demonstrates regular screen plate process, and screen prints on paper.
R. Fischer patents tripack process with colour couplers in three-layered emulsion.

1913 Paget Colour plates sold.
Raydex print process introduced.
Leto colour plates introduced.

1914 Hicro Universal colour camera introduced.
Improved Paget print process demonstrated by Whitfield.
Kodachrome two-colour process for portraiture introduced.

1915 Workman patents triple camera design for colour.
Ives' Hicro printing process introduced.

1916 Agfa Colour plates introduced in Germany.
Ives' Hiblok tripack negative process.

1917 Dufay Versicolor plates replace Dioptichrome.

1923 Keller-Dorian, Berthon lenticular colour movie process demonstrated.

1924 Jos-Pe camera patented, and dye transfer printing process.
Mannes and Godowsky patent two-layer colour process.

1925 Jos-Pe camera introduced.

1926 Baker Duplex colour plate process sold.
Lignose Natural Colour films introduced.

1928 Kodacolor lenticular film introduced for 16 mm movies.
Leitz markets 35 mm filmstrip projector for lenticular colour films.

1929 Finlay Colour plate process introduced.
Duxochrome process launched.
Colorsnap process marketed in UK, and similar Agfa-Ansco Colorol in USA.

1930 Hillman colour camera patented, and sold by Adam Hilger.
Oliver's automatic repeating back patented.
Mannes and Godowsky join Kodak Research Laboratories.

1931 Piller additive colour print process marketed.
Finlaychrome combined screen plates on sale.

Lumière Filmcolor screen films launched.
Vivex colour print process perfected.

1932 Amira separate tripack process introduced.
Agfacolor screen films on sale.
Ives' two-colour Polychrome process introduced.
Spicer-Dufay colour cinefilms introduced.

1933 Gasparcolor process launched.
Agfacolor lenticular film introduced.

1934 Ultra Agfacolor film sold.

1935 Kodachrome film introduced in 16 mm movie form.
Dufaycolor roll and sheet films launched.
Defender Chromatone print process marketed.
Eastman Wash-off Relief process introduced.

1936 Kodachrome film in 8 mm, 35 mm and 828 rollfilm forms introduced.
Agfacolor Neue, integral tripack film launched in 16 mm movie and 35 mm still forms.

1937 Coloretta 35 mm colour camera patented.

1938 Introduction of ready-mounting service for Kodachrome film transparencies.
Improved Kodachrome film processing method.
Kodachrome Professional sheet film marketed.

1940 Flexichrome hand colouring system introduced.
Agfacolor negative-positive cinefilm process developed.
Eastman Aero colour films developed for military use.
Sakura Natural Color film produced in Japan.

1941 Minicolor and Kotavachrome prints available from Kodachrome film transparencies.

1942 Anscocolor film produced for military use.
Agfa colour paper produced on small scale.
Kodacolor films and papers introduced in USA.

Glossary

Additive colour process One in which red, green and blue coloured positive images, derived from separation negatives (qv) are combined by optical means. They may be projected in superimposition by three projectors, or combined by systems using transparent reflectors, or may be combined on a single plate with minute colour filter elements which blend in the eye when seen from a distance.

Albumen paper Introduced by Blanquart-Evrard in 1850. By coating paper with egg-white, before sensitising by a method similar to that of salted paper (qv), a smoother, slightly lustrous surface was produced, capable of recording finer detail. It remained in general use until the 1890s, when for most purposes it was superseded by gelatin papers (qv).

Amalgam A mixture of two or more metals; in photography, mercury amalgamated with silver forms the Daguerreotype image.

Aniline dye A synthetic dye derived from aniline or other products of coal tar.

ASA speed see **Emulsion speed**

Bipack A pair of negative plates or films placed emulsion to emulsion, each sensitised to a different part of the spectrum and one being exposed through the other.

Cabinet photograph A popular size of photograph, mounted on card about 4 × 5½ inches, in general use from 1866 until the early years of this century.

Calotype The process discovered by William Henry Fox Talbot in 1840, in which an invisible, latent image produced by exposure of sensitised paper was made visible by a process of development. The paper negative was printed on salted paper (qv).

Carbon tissues A pigmented gelatin layer, sensitised with potassium bichromate, carried on a temporary paper support from which the layer could be stripped after exposure.

Carte de visite photograph Small mounted photograph, measuring about 4 × 2½ inches, introduced in the late 1850s, and popular until the early years of this century.

Collodion A solution of guncotton in ether, or alcohol and ether. The guncotton was formed by dissolving cotton wool in a mixture of nitric and sulphuric acids. It was discovered in 1847, and was first used as a permeable dressing in medicine. It was used by Frederick Scott Archer for the wet collodion process (qv), and collodion coatings were used in the preparation of a number of screen-plate and other processes.

Complementary colours Two colours of light, which when mixed produce a sensation of white light. Cyan (blue-green) is complementary to red, magenta to green and yellow to blue.

Coupler A substance which reacts with the chemical products of development to form a dye, in proportion to the amount of reduced silver formed.

Cyanotype A process discovered in 1842 by Sir John Herschel. Paper was sensitised by brushing with a solution containing an iron salt and potassium ferricyanide. When exposed to light, the paper turned blue, and the image could be fixed by simple washing, leaving a cyan image on white. The process was used for blue-prints, and in some colour processes.

Daguerreotype The name given to the process discovered in 1837 by L. J. M. Daguerre, and announced in 1839. The image formed on the silvered surface of a copper plate, sensitised by iodine vapour, was developed with mercury vapour. Used primarily for portraiture, the process went out of general use in the late 1850s.

Development In photography, a process whereby an invisible or latent image is made visible by chemical treatment. In the carbon

processes, the development was carried out with warm water, which dissolved away unhardened, unexposed portions of the gelatin layer.

Dichroic dye A dye whose colour varies with its concentration.

Dissolving view A projection technique using two magic lanterns. One picture could be made to blend slowly into the next, by lowering the illumination from one lantern, while simultaneously raising that of the other.

Emulsion A suspension of minute droplets of oily or other water-insoluble liquid in water. In photography, the term is used also to describe a suspension of light sensitive chemicals in a substance such as gelatin.

Emulsion speed The first comprehensive system for the determination of the sensitivity, or speed, of photographic materials was worked out by Ferdinand Hurter and Vero Driffield in the 1880s. Their method produced an 'H & D' number for each type of plate, from which the exposure necessary could be calculated. Their method was widely used until the Second World War. Other systems of speed measurement have been used over the years. Today, most films are rated in either the American ASA or the German DIN methods.

Film pack A device for holding a number of sheet films in a camera, devised by J. E. Thornton and introduced in 1903. Each sheet film is attached to a long paper tab, and after exposure each sheet is transferred from the front to the back of the pack by pulling on the tab.

Filter A light-transmitting material, usually dyed gelatin or glass, which absorbs selectively certain colours. Filters which transmit one third of the visible spectrum (qv), passing red, green and blue light respectively, were extensively used in colour photography.

Fixing In photography, the process of removing the unused light-sensitive salts from exposed and developed photographic materials.

f/number The light-gathering capacity of the lens, the number being obtained by dividing the diameter of the lens opening into the focal length of the lens. Thus, the larger the aperture of the lens, the smaller the f/number.

Gelatin papers Papers coated with a layer of gelatin containing light-sensitive salts. Gelatin papers came into use in the 1880s, and by 1900 had largely replaced the earlier albumen papers.

H & D **speed** see **Emulsion speed**

Hydrotype see Imbibition printing.

Imbibition printing A process whereby a dye image is transferred from a gelatin relief image, or from a gelatin layer differentially hardened, to a paper or film coated with a receiving layer, usually of gelatin.

Isochromatic see Orthochromatic.

Lenticular film Film having small cylindrical or spherical lenses embossed into the transparent base.

Masking In black and white photography, a method of reducing contrast in the negative by binding it up in register with a weak positive transparency made by contact printing. In colour photography, positive masks produced from and used with separation negatives were used to correct for deficiencies in the dyes used to make the prints. Modern colour negative materials normally incorporate automatic colour masking methods.

Mercury A metal which is liquid at room temperatures. Mercury vapour was used to develop the Daguerreotype image, and was used in the Lippman colour process to provide a reflecting surface behind the plate.

Negative The image formed after exposure and development. The tones of the negatives are reversed, the light parts of the subject being dark in the negative, and the dark, light.

Orthochromatic A photographic material sensitive to blue, green and yellow light. To correct for an excess of blue sensitivity, such materials were normally exposed through a yellow filter. Also known as Isochromatic materials.

Panchromatic A photographic material sensitive equally to all colours.

Photogenic drawing A process developed by W. H. F. Talbot in 1834, and announced in 1839.

Paper was treated with solutions of common salt and silver nitrate, producing light-sensitive silver chloride in the paper. Prolonged exposure to light caused the paper to darken in proportion to the intensity of light reaching it.

Positive A print, made from a negative (qv), in which the tones of the original are restored.

Primary colour The three colours red, green and blue. Light of these three colours, when mixed in various proportions, can produce all other colours. White light is produced from a mixture of all three. The artist's primary colours, red, blue and yellow, are in reality the complementary colours magenta, cyan and yellow.

Prism A glass block of triangular section. A ray of light, passing through a prism, is broken up into its component colours, producing a spectrum (qv).

Relief image In photography, an image, usually in gelatin, in which the various tones of a photograph are represented by varying thicknesses of the coating. Highlights are represented by a thin layer, shadows by a thick layer.

Repeating back A device on a camera which permits the plateholder to be moved after exposure, to permit a second negative to be taken adjacent to the first on the same plate. Repeating backs permitting three exposures to be made were used for a number of colour processes.

Reversal development A process whereby, after negative development, the image is bleached away and the remaining silver salts are developed to produce a positive image.

Salted paper The sensitised paper originally devised by W. H. F. Talbot for his photogenic drawing process (qv), later used for printing from calotype (qv) negatives. It was superseded by albumen paper (qv) in the 1850s.

Sensitising dye A dye which, when added to a photographic emulsion, extends its sensitivity to colours other than blue. Generally, the dye sensitises for a colour complementary to its own.

Separation negatives A set of negatives, exposed through red, green and blue filters, which analyses the scene in terms of its content of those three colours.

Shutter A mechanical device placed before, in or behind the lens, which can be opened and closed for a controlled length of time to permit exposure of the plate or film.

Spectrum A band of pure colours formed when white light is passed through a prism (qv). The principal colours observed are violet, indigo, blue, green, yellow, orange and red. The rainbow is a naturally occurring spectrum, produced by the dispersion of sunlight through raindrops.

Squeegee A device, usually with a rubber blade or a roller, used to bring two papers or films in close contact.

Stereoscopic pictures Vision in depth is produced when the brain fuses the slightly dissimilar images provided by the eyes, separated by several inches. If two photographs are taken from similarly different viewpoints, and are viewed in a stereoscope – a device permitting the left eye to see only the left-hand picture and the right eye to see only the right-hand picture – the result is a picture with apparent depth.

Tannin process A variant of the wet collodion process (qv) in which the sensitised plate was treated with a tannin solution which caused the plate to retain its sensitivity for much longer than usual.

Toning The conversion of the silver of a photographic image into a coloured substance, or its replacement with a coloured substance by chemical means. In dye toning, the silver image is replaced by a dye.

Tripack Three films or plates combined in a pack, or three emulsion layers coated on one film, so that the three separation negatives (qv) are produced by a single exposure.

Ultra-violet Invisible radiation beyond the violet end of the spectrum (qv), to which most photographic materials are sensitive.

Wet collodion process A photographic method introduced by Frederick Scott Archer in 1851. A glass plate coated with a layer of collodion (qv) containing a suitable salt was sensitised immediately before use with silver nitrate, and was exposed while still wet. It fell from general use after the introduction of the gelatin dry plate process in the 1870s.

Bibliography

On the history of colour photography:

Friedman, J. S., *History of Color Photography*, American Photographic, Boston, 1944; reprinted, Focal Press, London and New York, 1968

Koshofer, G. R., *Colour Photography, its principles and processes*, article in sixteen parts in *British Journal of Photography*, London, 1976

Wall, E. J., *The History of Three-Color Photography*, American Photographic, Boston, 1925; reprinted, Focal Press, London and New York, 1970

Sipley, L. W., *A Half Century of Color*, Macmillan, New York, 1951

On historic colour processes:

Spencer, D. A., *Colour Photography in Practice*, Pitman/Greenwood, London, 1938

Mees, C. E. K., *From Dry Plates to Ektachrome Film*, Ziff-Davis, New York, 1961

Déribéré, M., (ed.), *Encyclopaedia of Colour Photography*, Fountain Press, Watford, 1962

Cornwell-Clyne, A., *Colour Cinematography*, Chapman & Hall, London, 1951

On the principles of colour photography:

Hunt, R. W. G., *The Reproduction of Colour*, Fountain Press, Watford, 1975

Evans, R. M., Hanson, W. T. and Brewer, W. L., *Principles of Colour Photography*, John Wiley, New York, 1953; Chapman & Hall, London, 1953

On the general history of photography:

Coe, Brian, *The Birth of Photography*, Ash & Grant, London, 1976

Gernsheim, H. and A., *The History of Photography*, Thames & Hudson, London, 1969

Newhall, Beaumont, *The History of Photography*, Museum of Modern Art, New York, and New York Graphic Society, Boston, 1972; Secker & Warburg, London, 1973

Index